NIK MASANGCAY ART BOOK

WELCOME! Published and printed in 2017 by TATAY JOBO ELIZES, Self-Publisher, under the expressed permission and authorization of the author, NIK MASANGCAY, who owns the copyright to all drawings and paintings displayed in this art book. Nik Masangcay can withdraw or rescind this permission without any objection from Talay Jobo Elizes at any time. Printing of this book is using the present day method of Pnnt-On-Demand (POD) system, where prints will never run out of copies to be available for posterity. The copyright owner is free to publish his paintings with other publishers and printers anytime. ISBN Codes for this issue are:

ISBN - 13: 978 – 1547252664 & ISBN - 10: 1547252669

Contact: job elizes@yahoo.com + Websites: http://tinyurl.com/mj76ccq + www.jobelizes6.wix.com/mysite

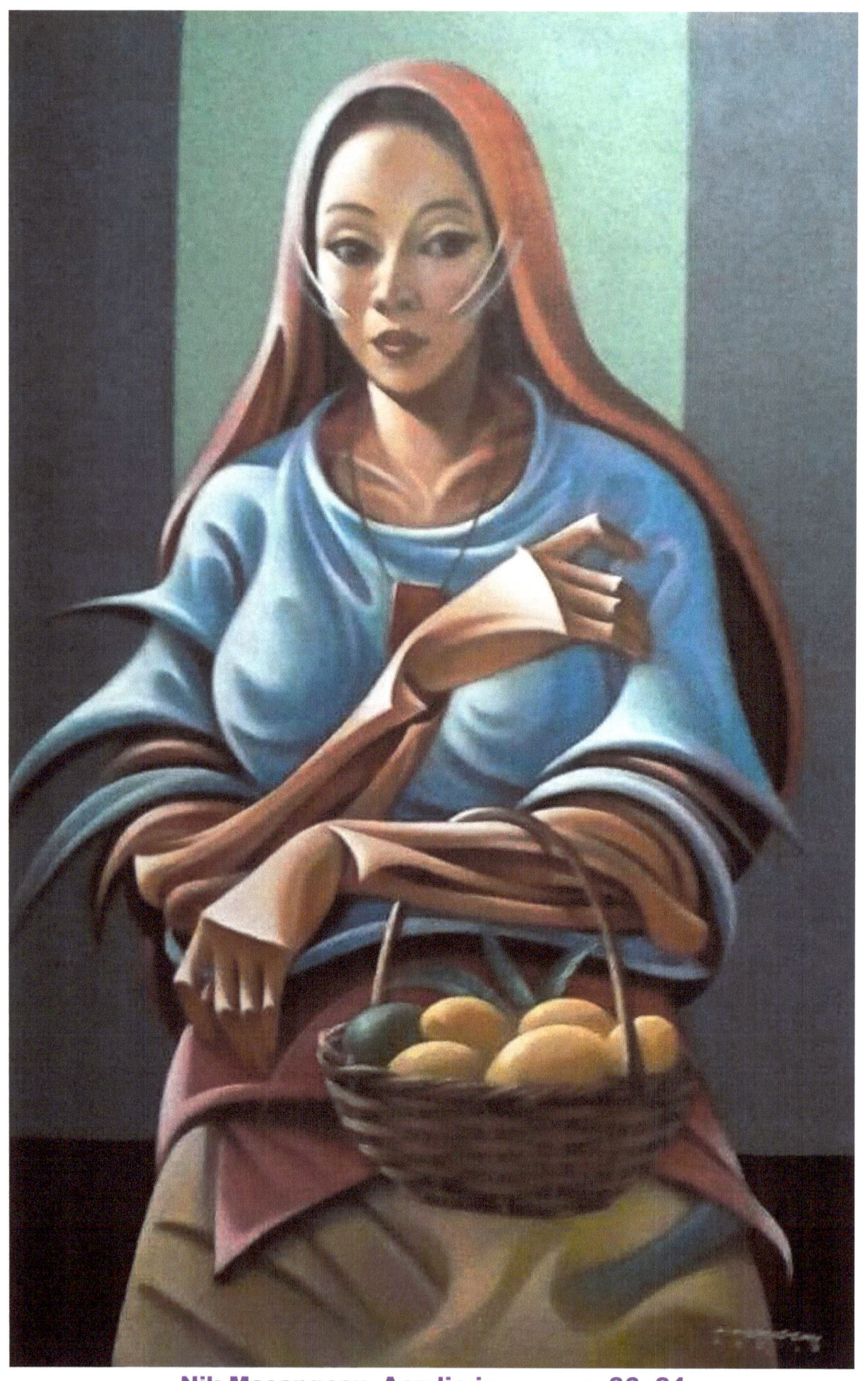

Nik Masangcay, Acrylic in canvas, 36x24

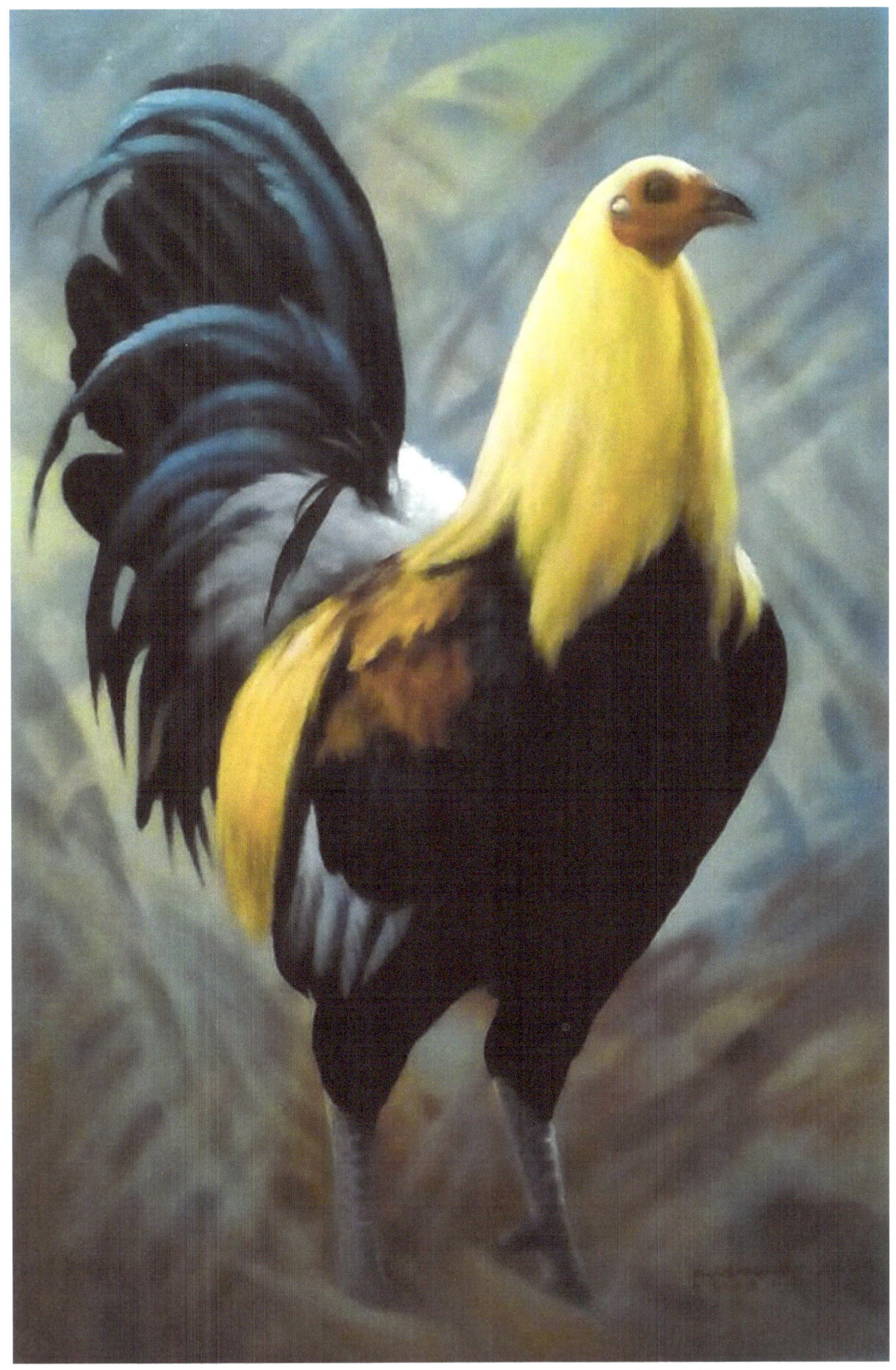

Nik Masangcay, Acrylic in canvas, 36x24

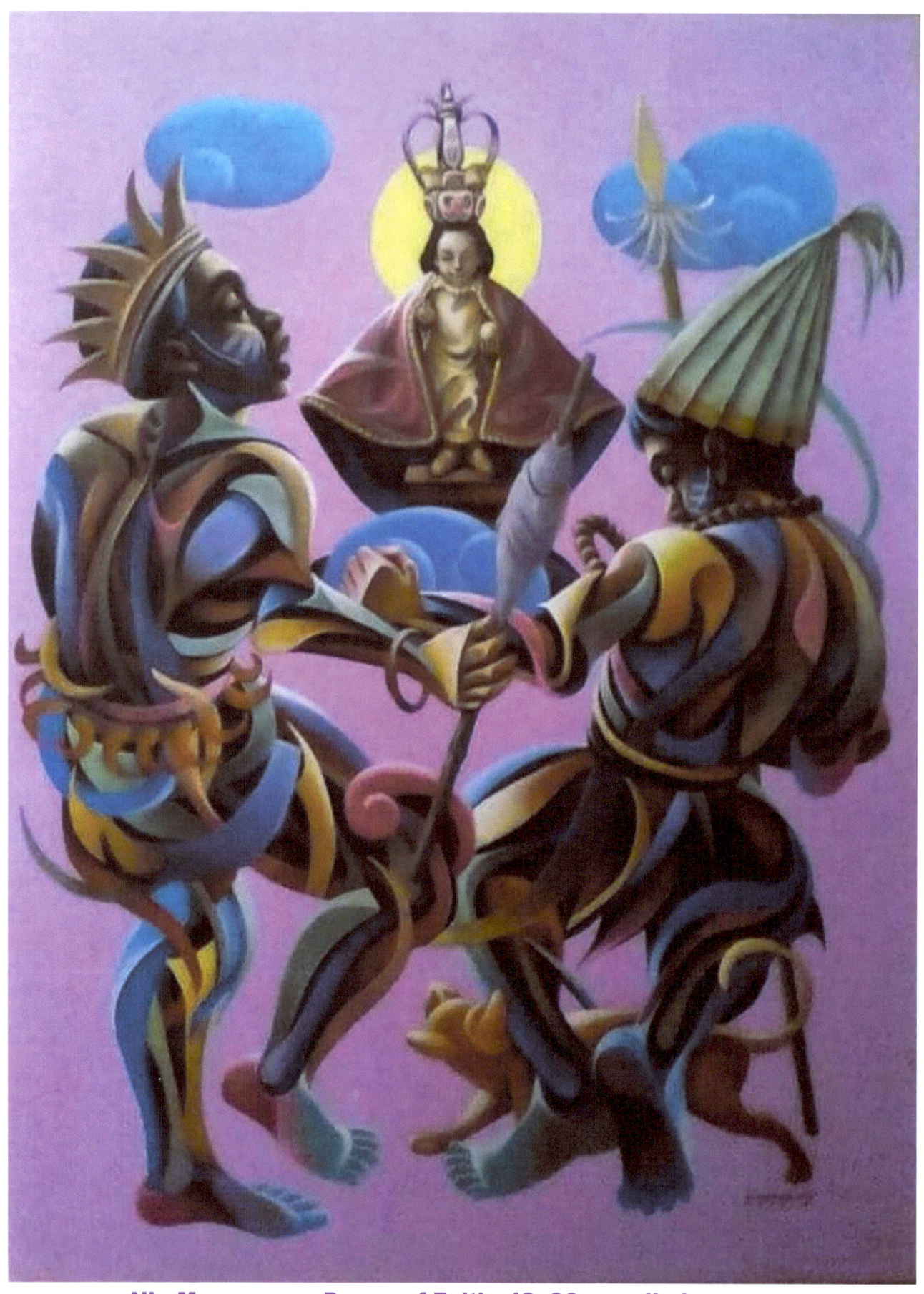

Nic Masangcay, Dance of Faith, 48x36, acrylic in canvas

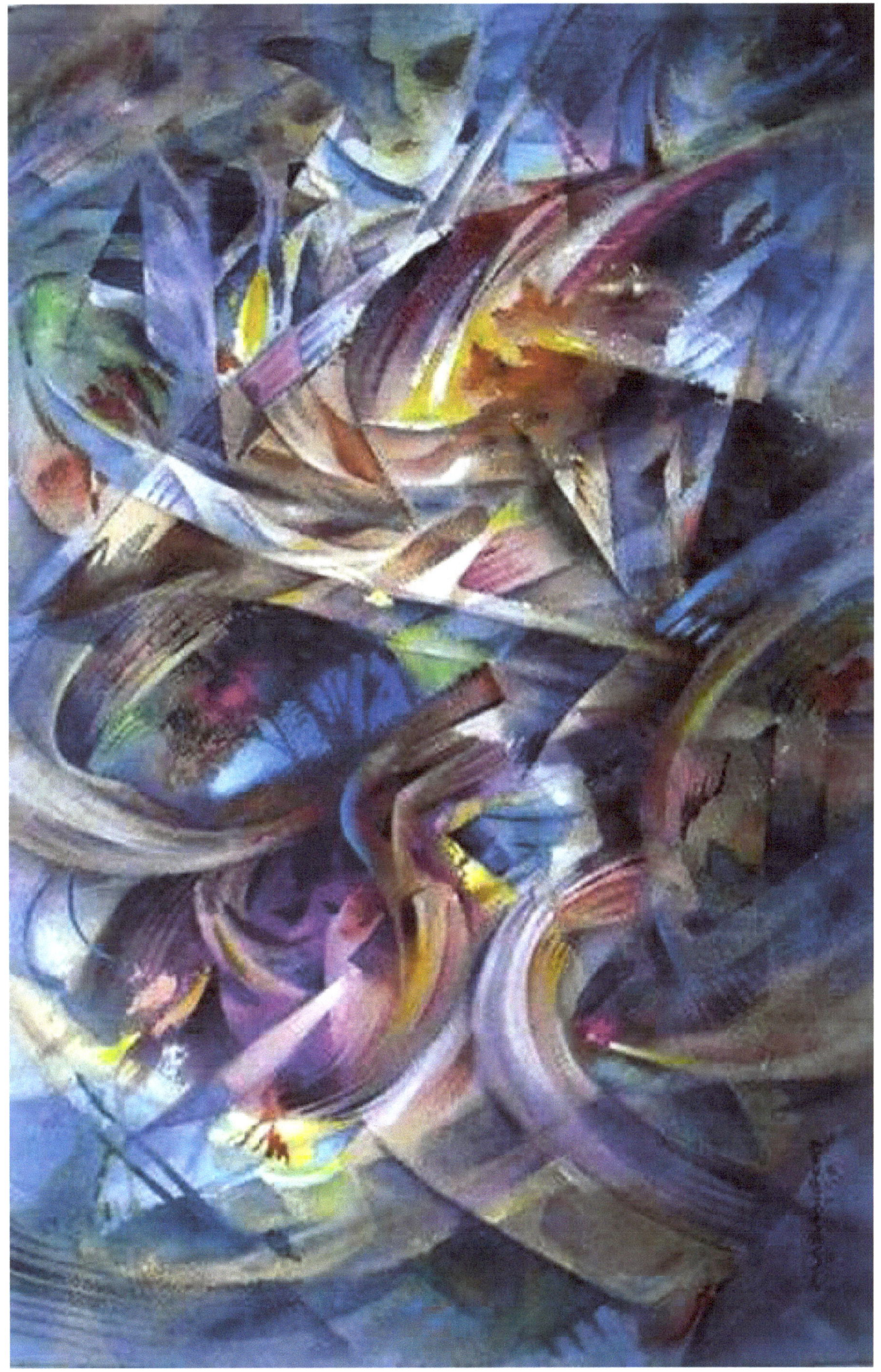

Nik Masangcay, Yakap, 14.5x21.5, watercolor

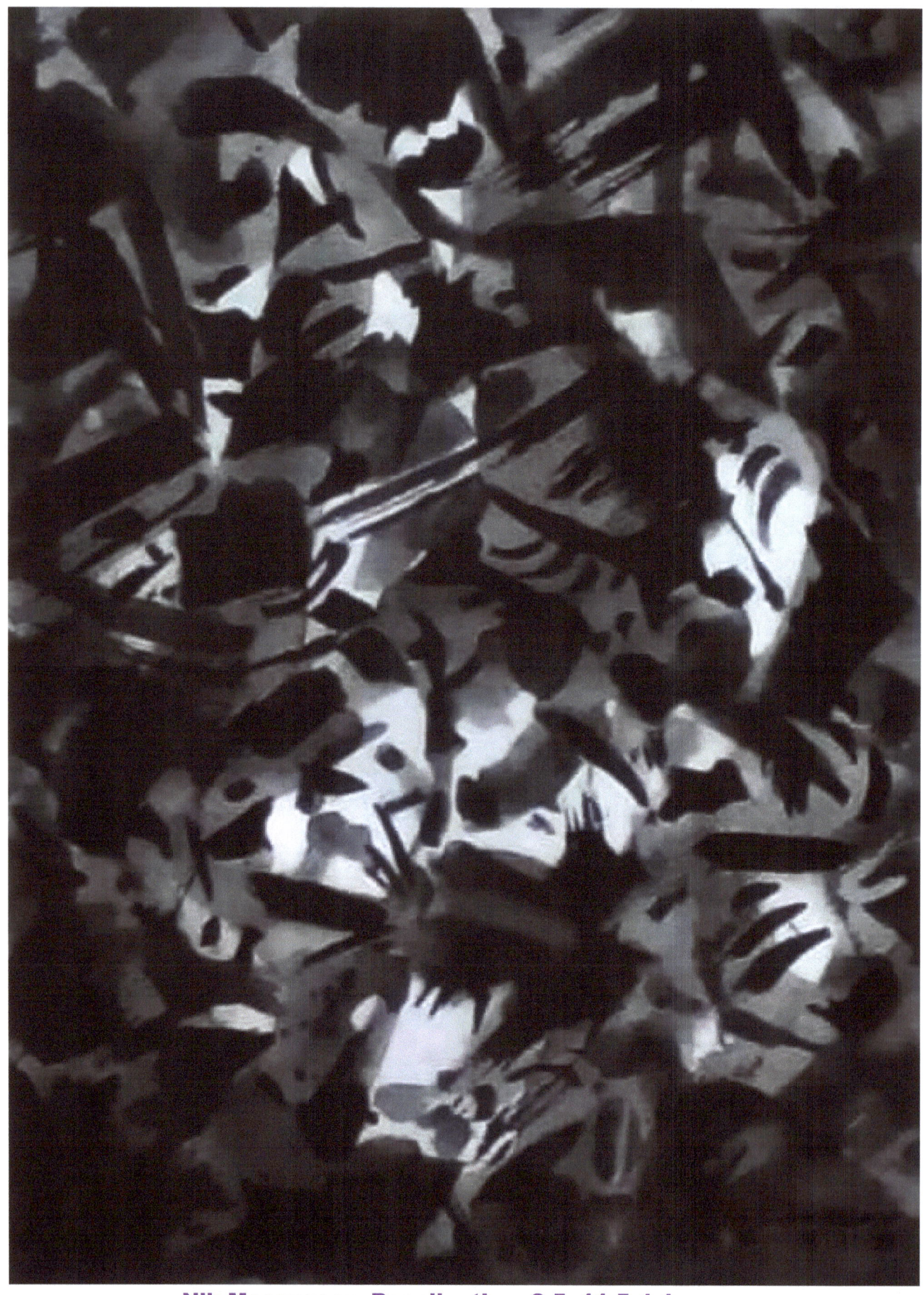

Nik Masangcay, Recollection, 8.5x11.5, inkpaper

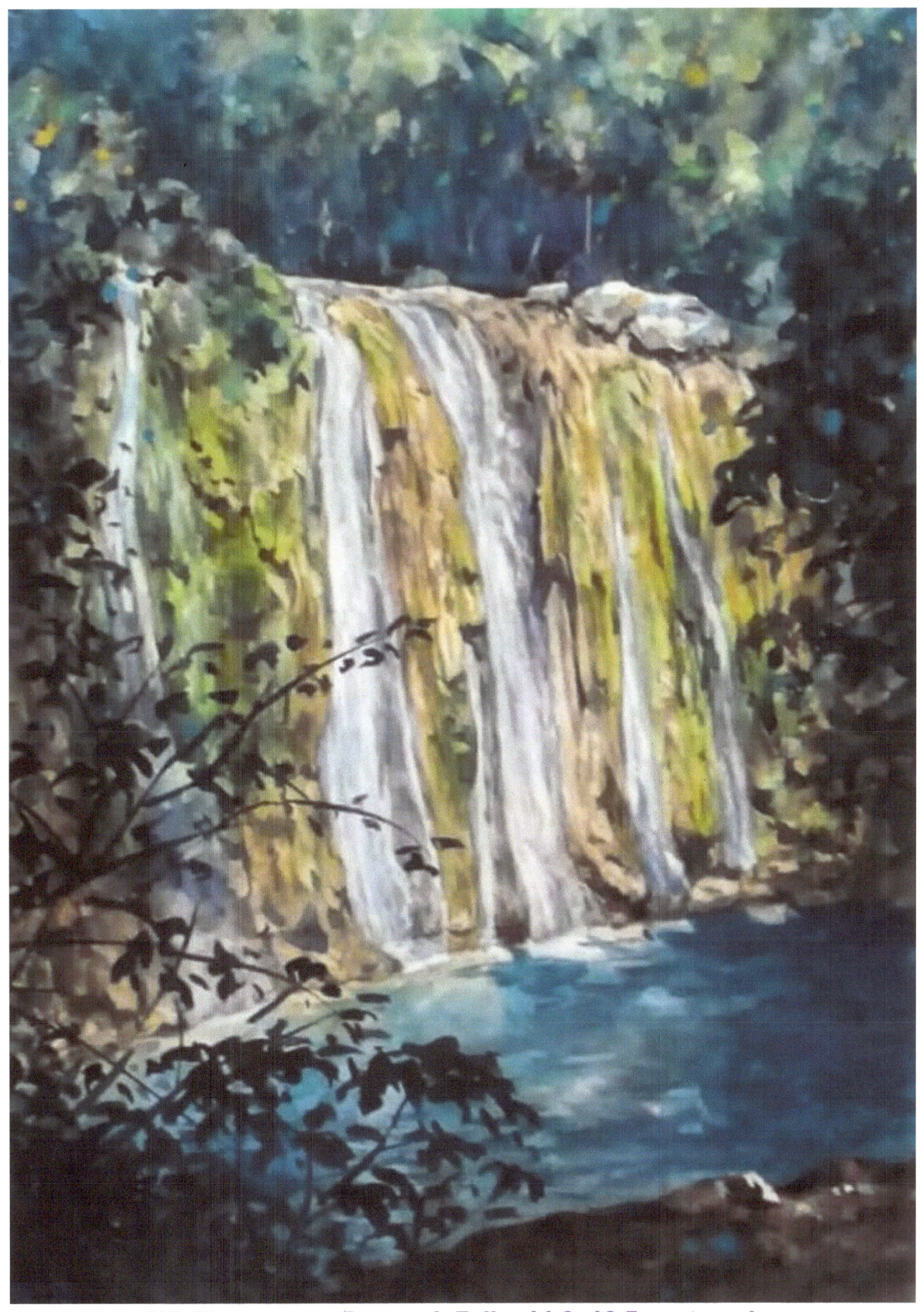

Nik Masangcay, Darawak Falls, 14.6x10.5, watercolor

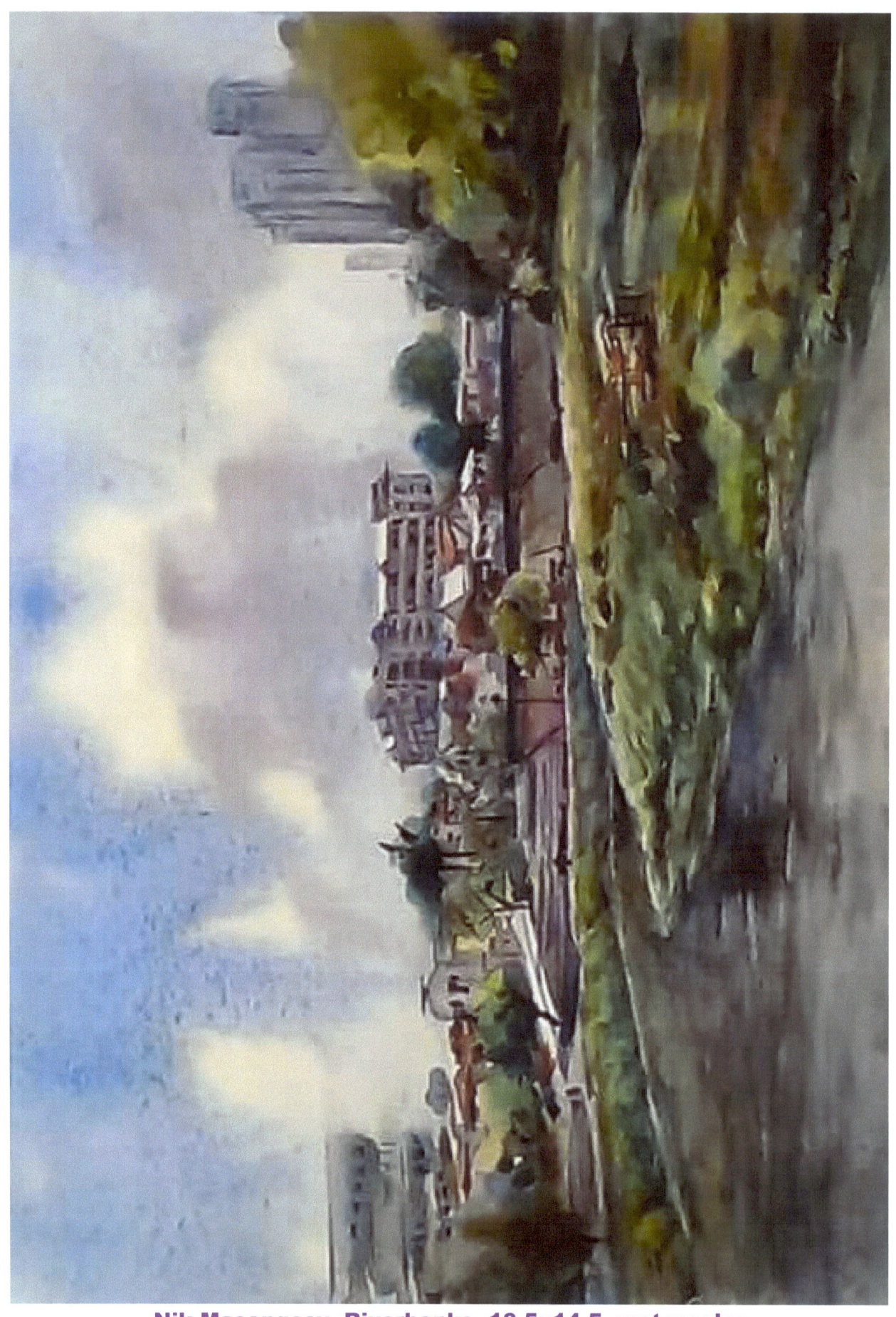

Nik Masangcay, Riverbanks, 10.5x14.5, watercolor

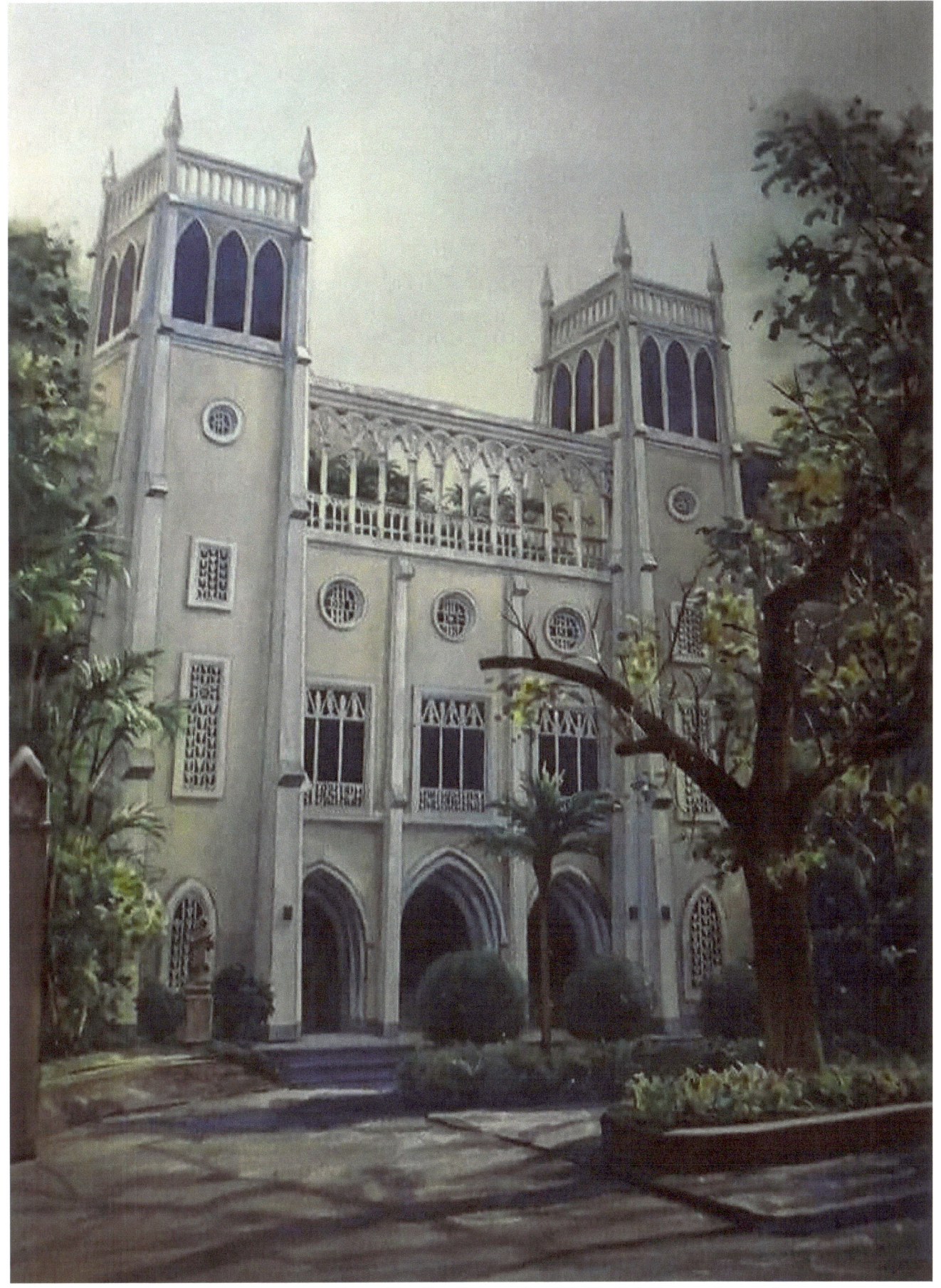

Nik Masangcay, San Beda Church, 29.5x21.5, watercolor

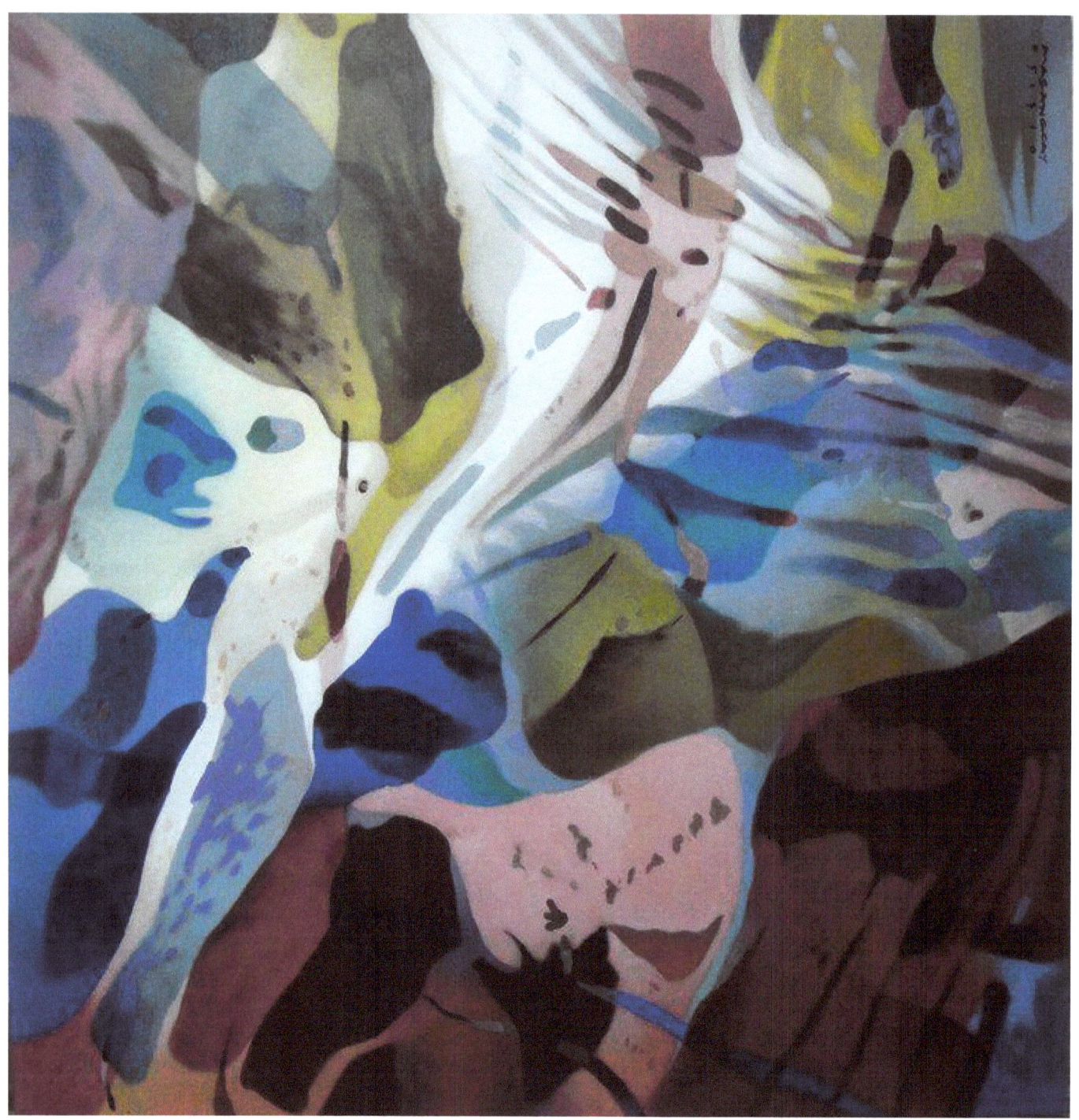

Nik Masangcay, Abstract

WELCOME! Published and printed in 2017 by TATAY JOBO ELIZES, Self-Publisher, under the expressed permission and authorization of the author, NIK MASANGCAY, who owns the copyright to all drawings and paintings displayed in this art book. Nik Masangcay can withdraw or rescind this permission without any objection from Talay Jobo Elizes at any time. Printing of this book is using the present day method of Pnnt-On-Demand (POD) system, where prints will never run out of copies to be available for posterity. The copyright owner is free to publish his paintings with other publishers and printers anytime.

Each page is suitable for framing, Just cut it out. This book is good conversation piece and for display in living rooms and coffee tables. Also good for gifts for any occasion.

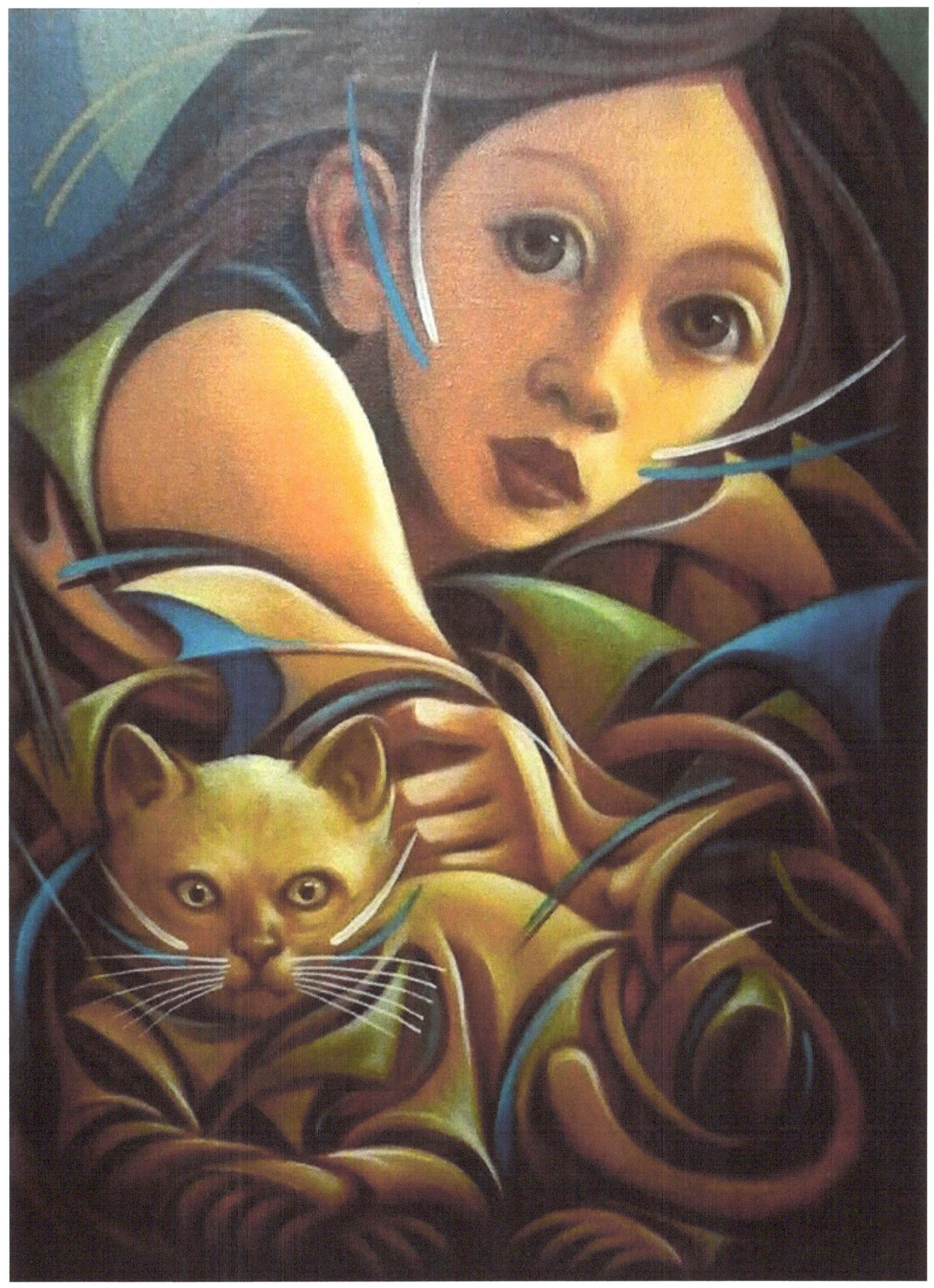

Nik Masangcay, acrylic on canvas

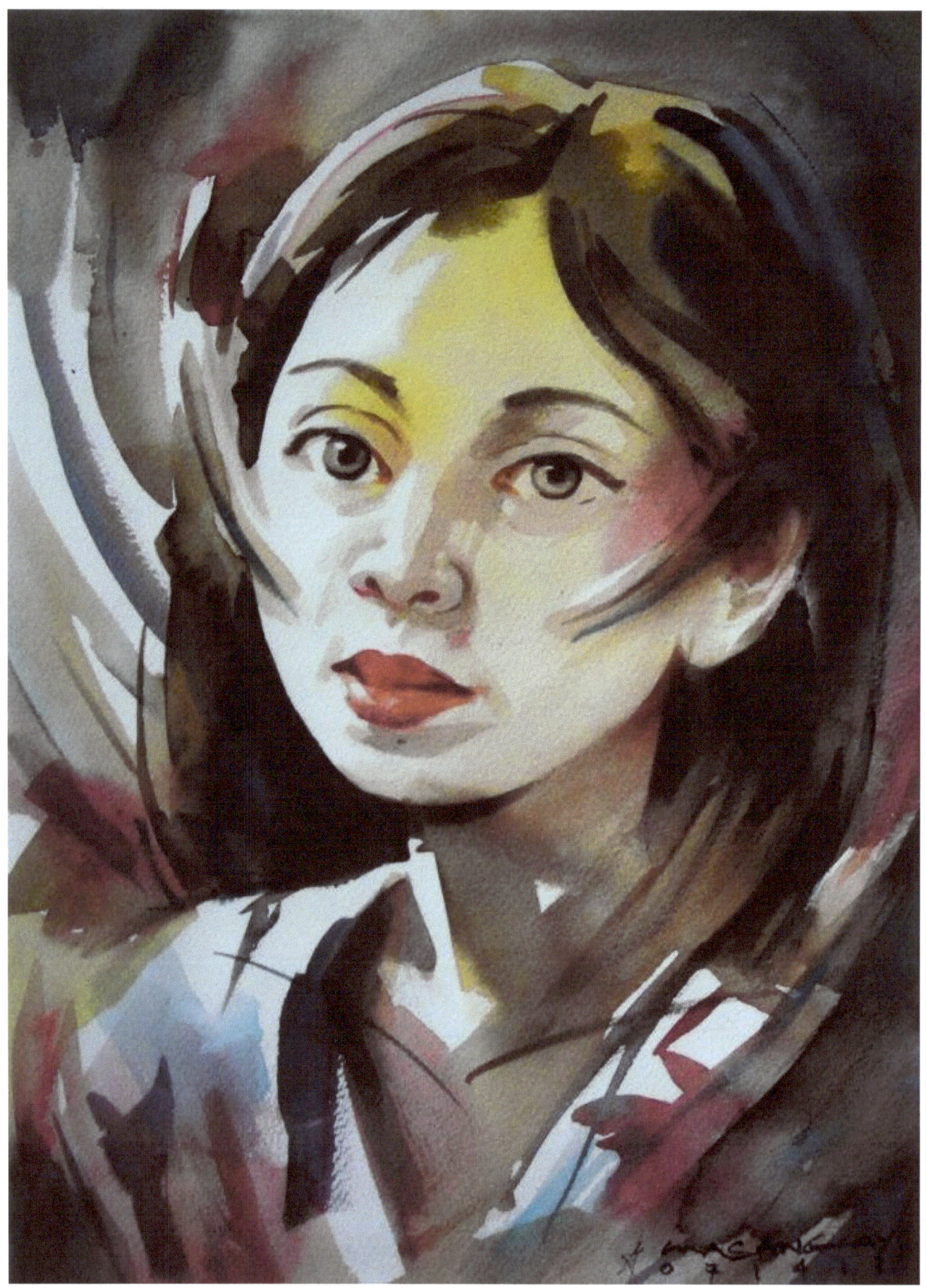

Nik Masangcay

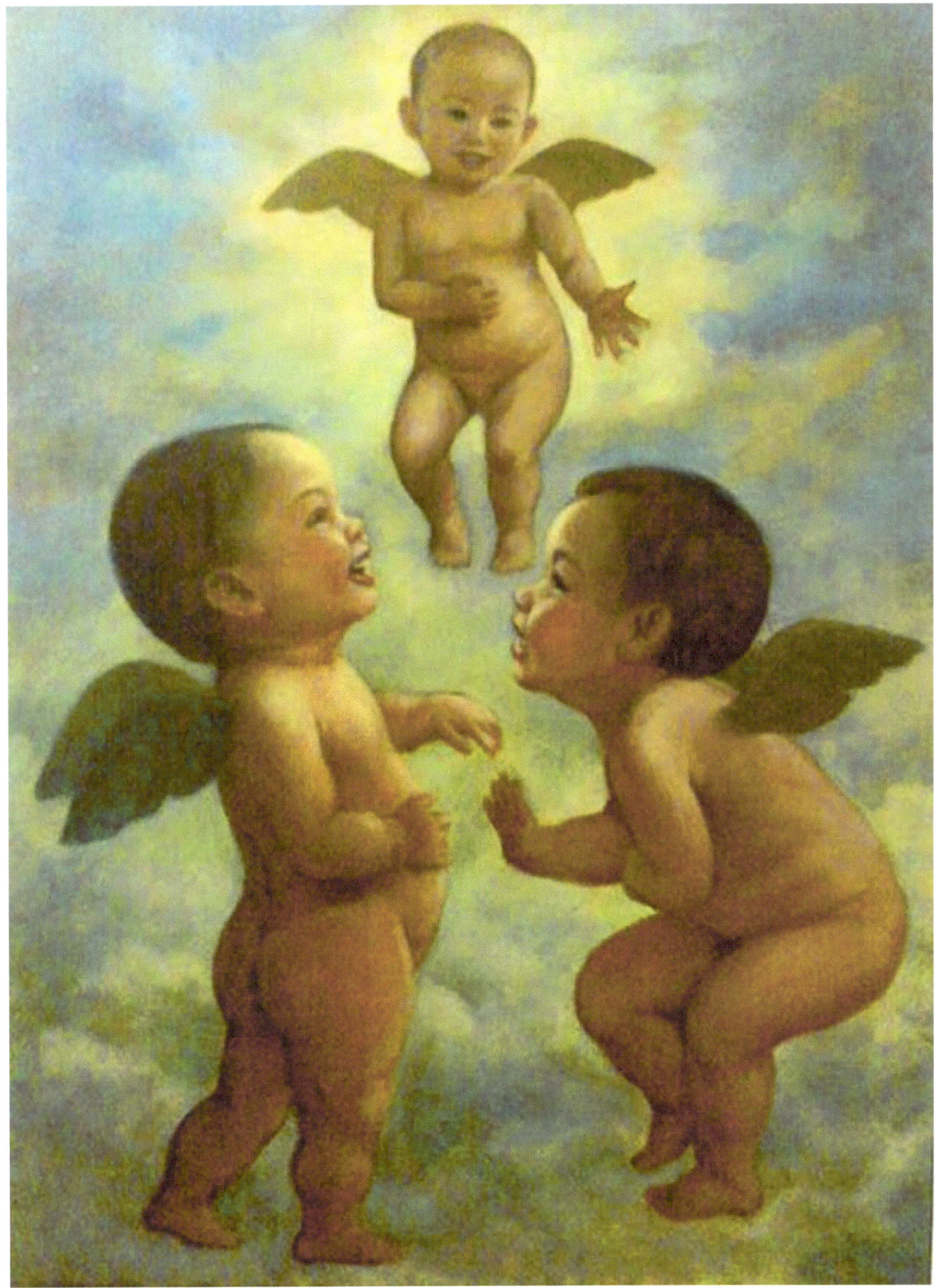

Nik Masangcay, Little angels

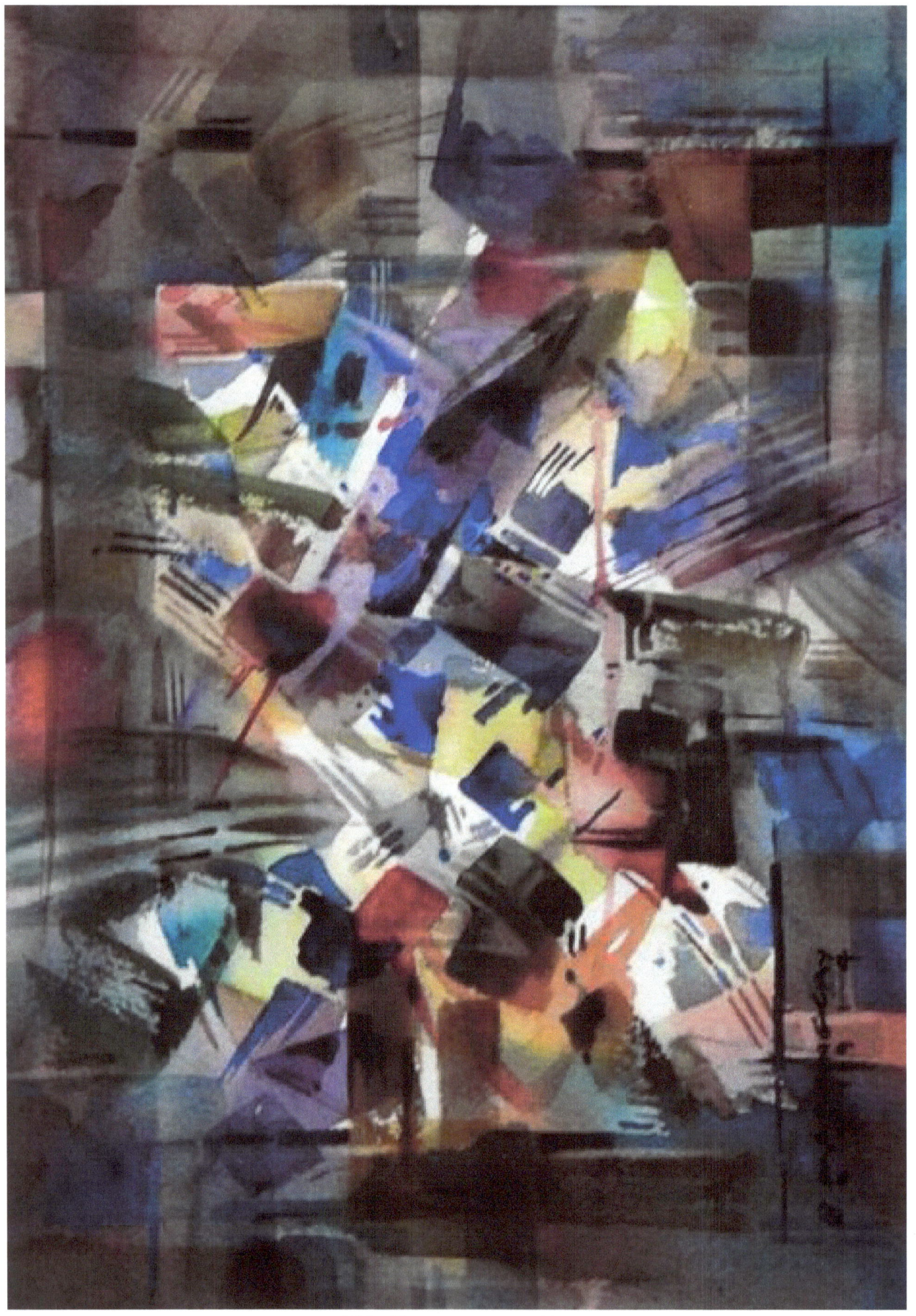

Nik Masangcay, Abstract

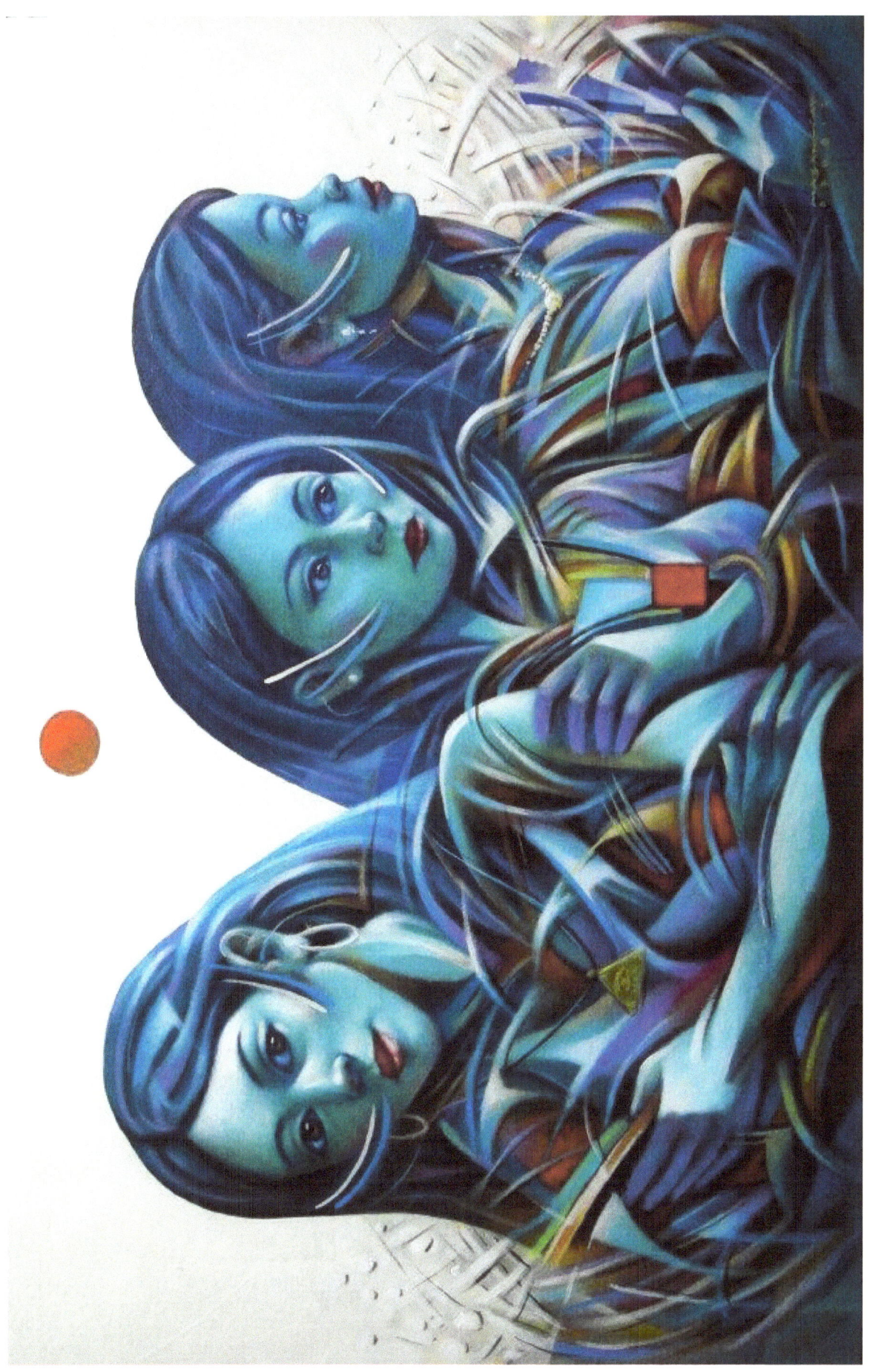

Nik Masangcay, Solemn ladies, acrylic on canvas

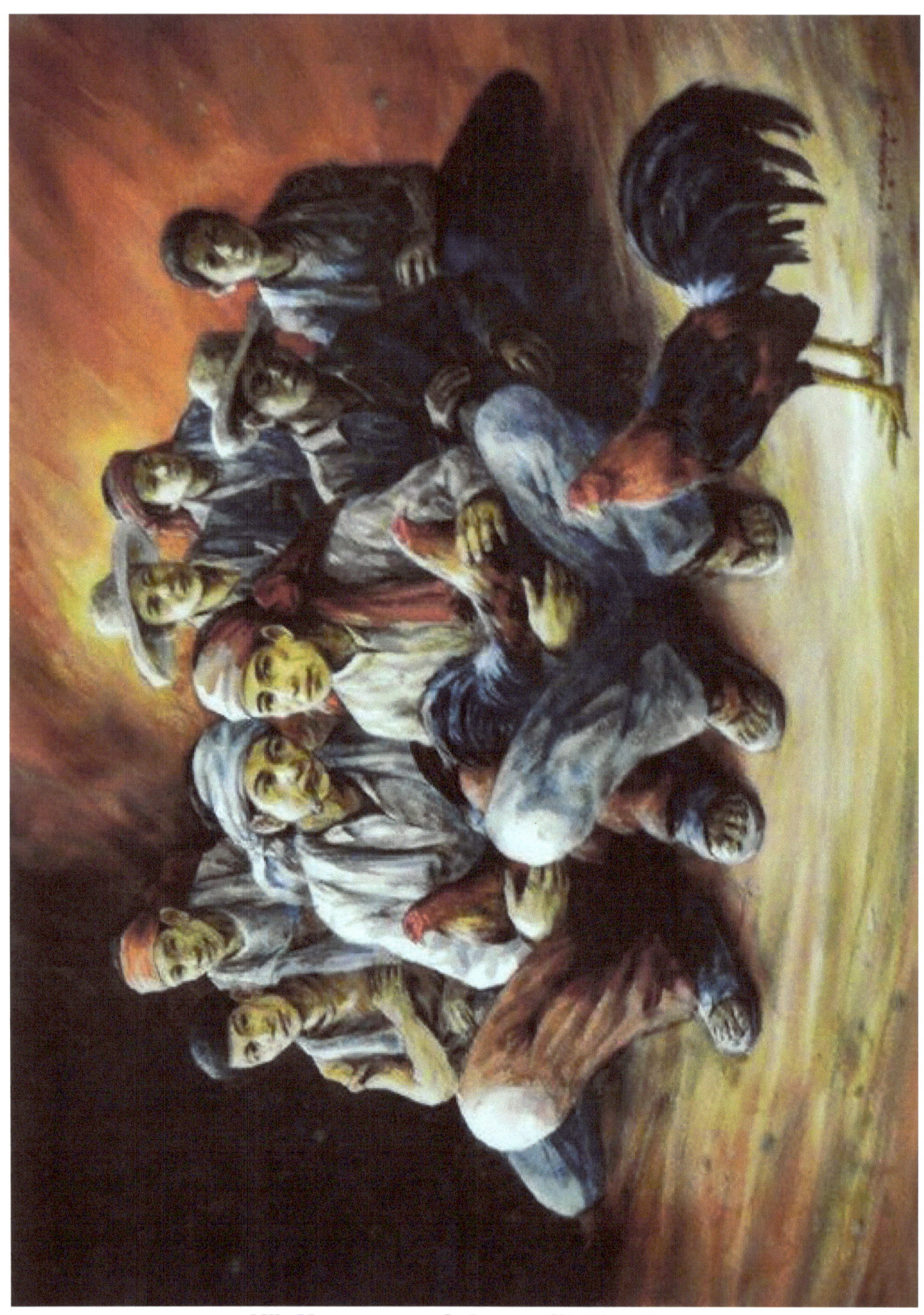

Nik Masangcay, Sabong afficionados

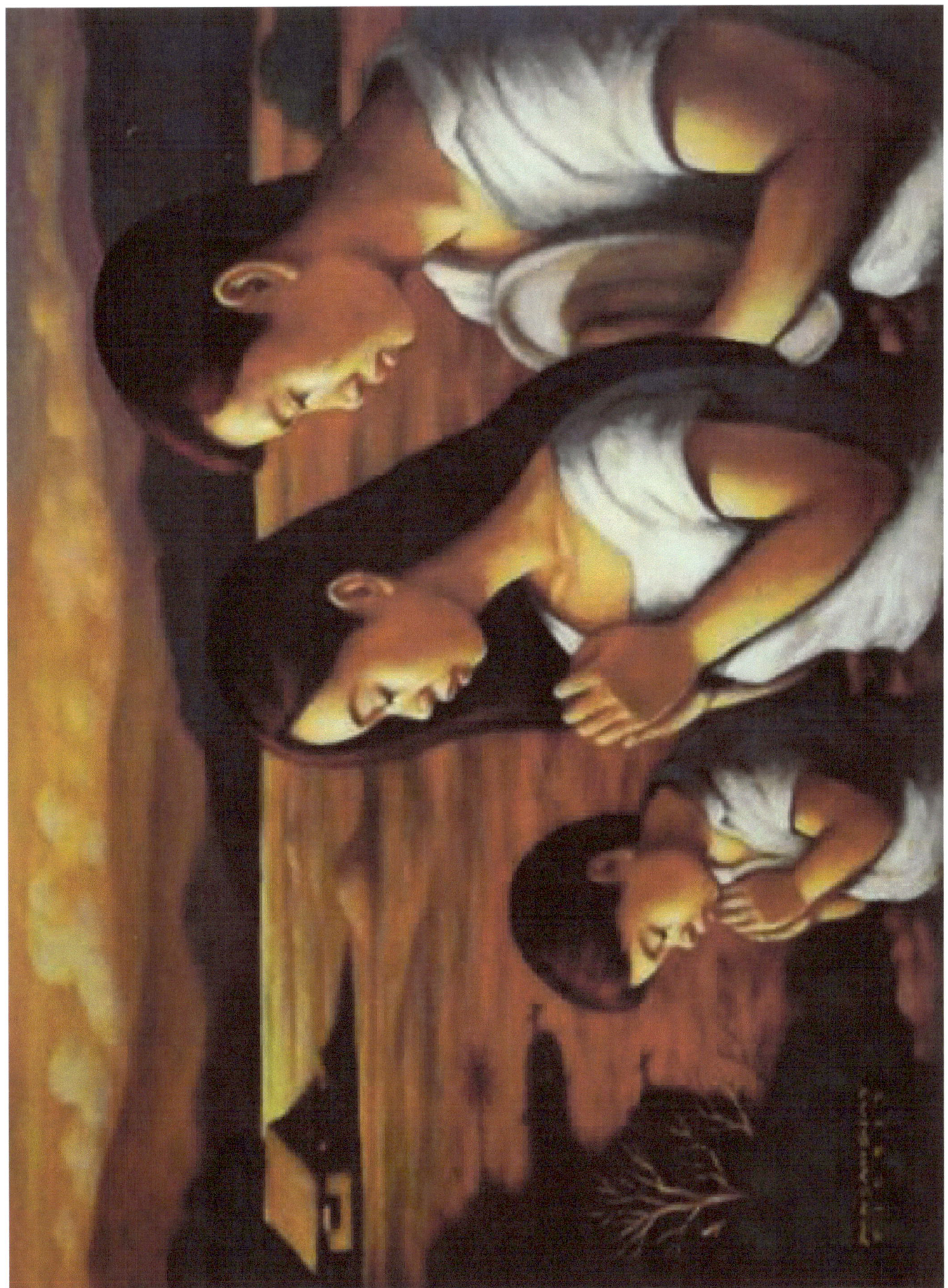

Nik Masangcay, Salamat Po

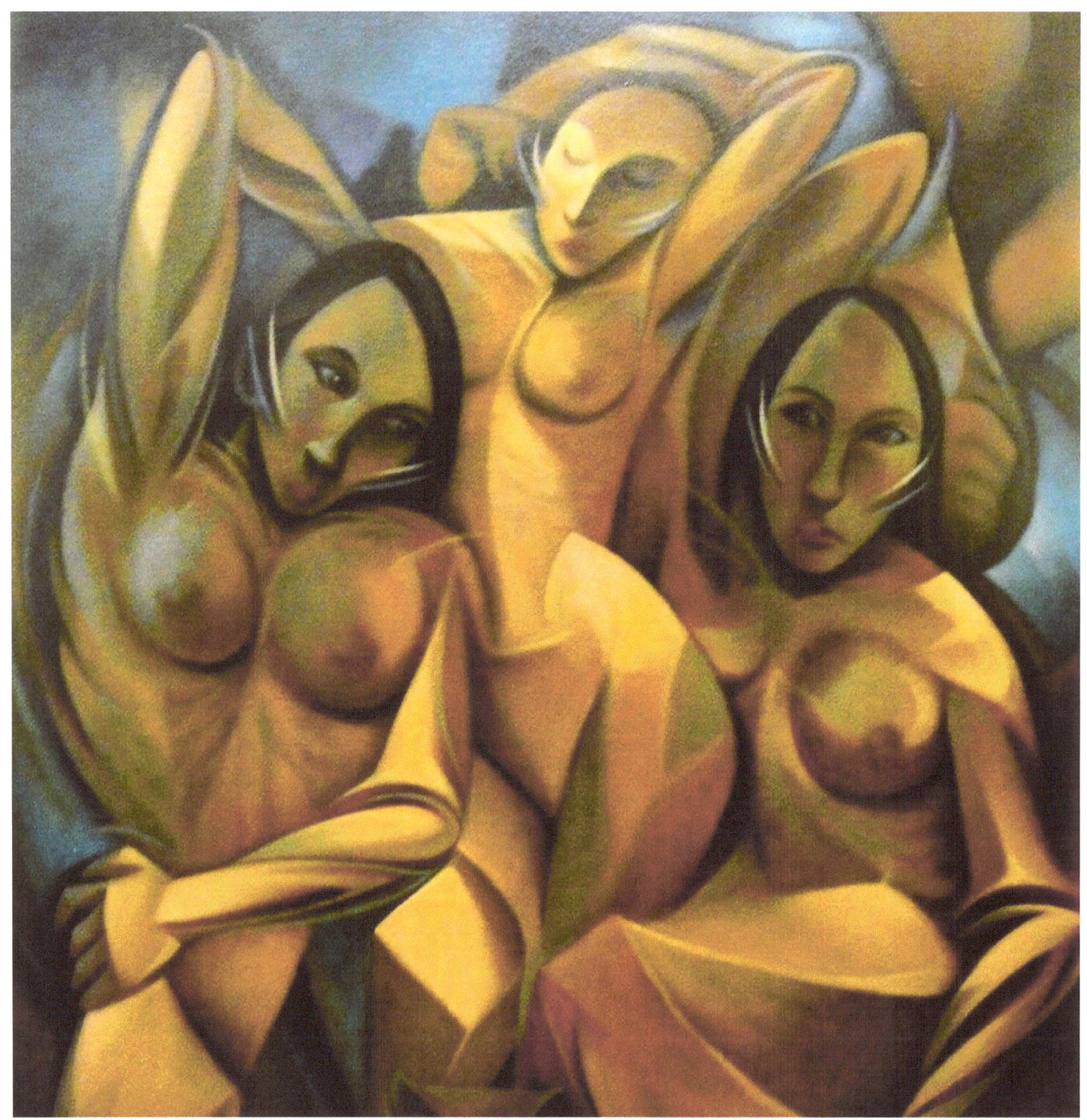

Nik Masangcay, Abstract Nudes study

Thank you and we hope you enjoyed this artbook. The artist can be contacted at facebook, under NIK MASANGCAY ARTHUB. He can be commissioned to do art work for you. Some of his works are available for sale. Just ask him. This book displays only 40 pieces. He has more than 200 pieces. Each page here can be cut out for framing and wall décor. This artbook is suitable for giveaway or gifts, any occasion. It's suitable for display in sala or living room and coffee table. It's perfect as conversation piece.

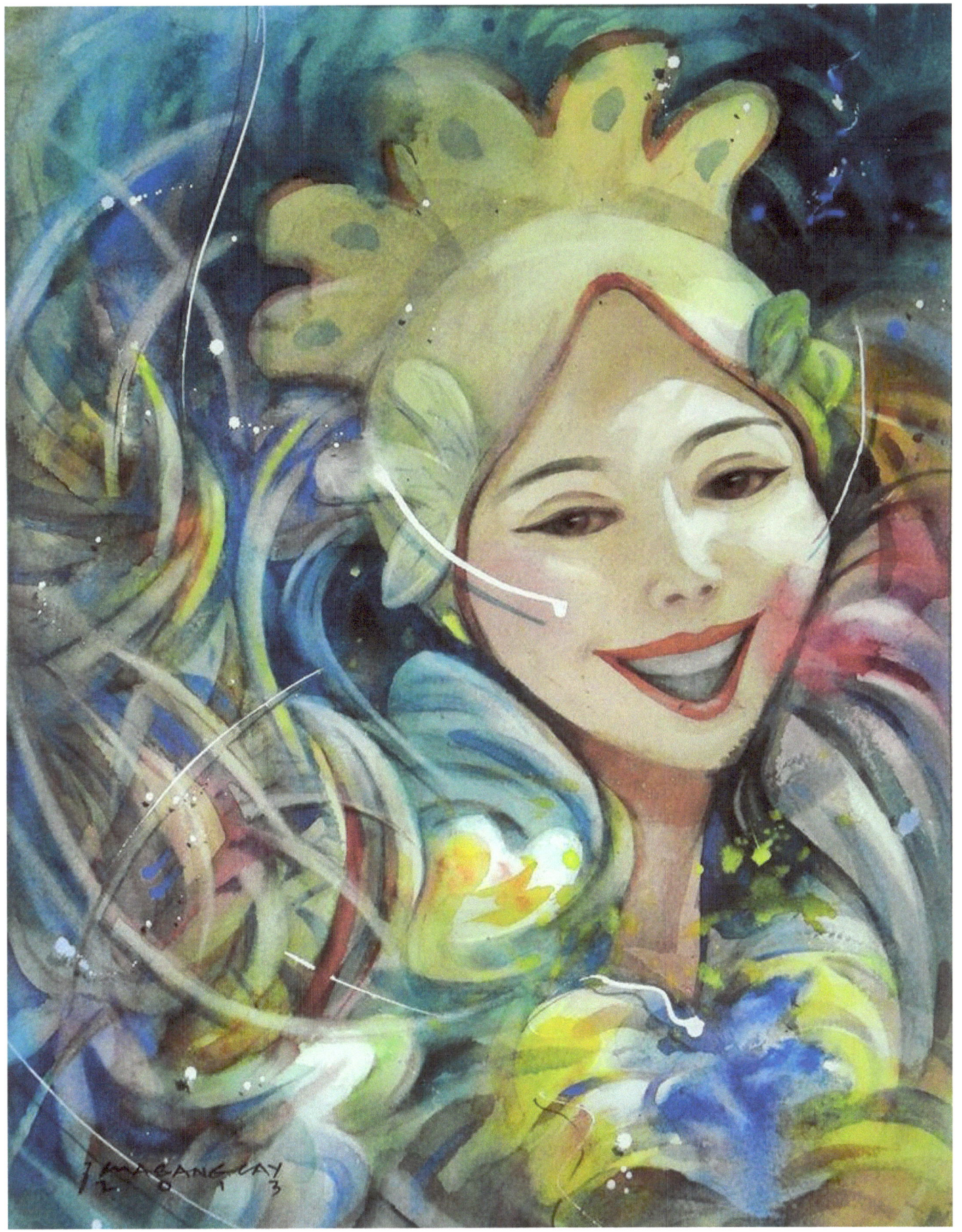

Nik Masangcay, Circus lady

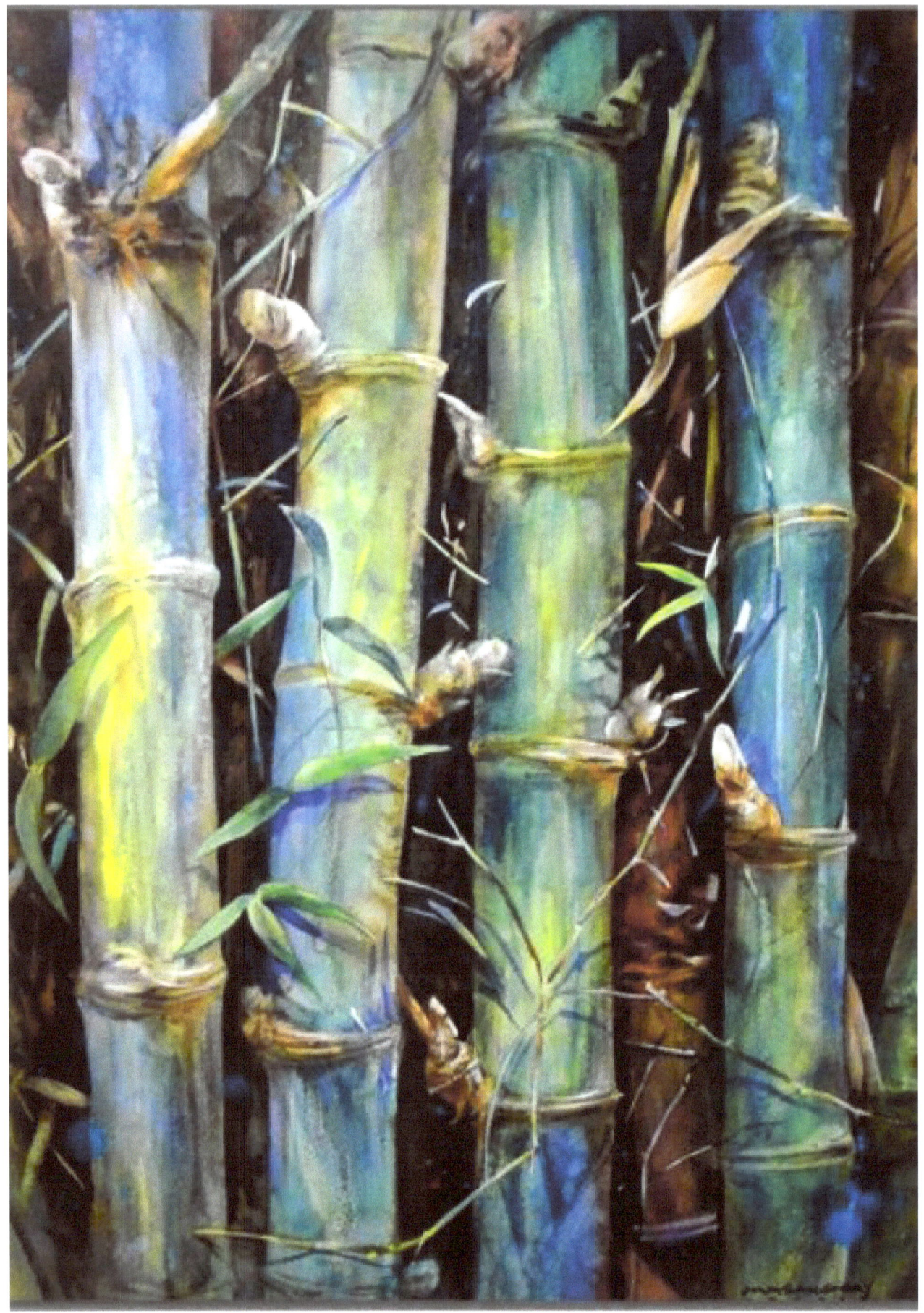

Nik Masangcay, Sturdy bamboo trunks

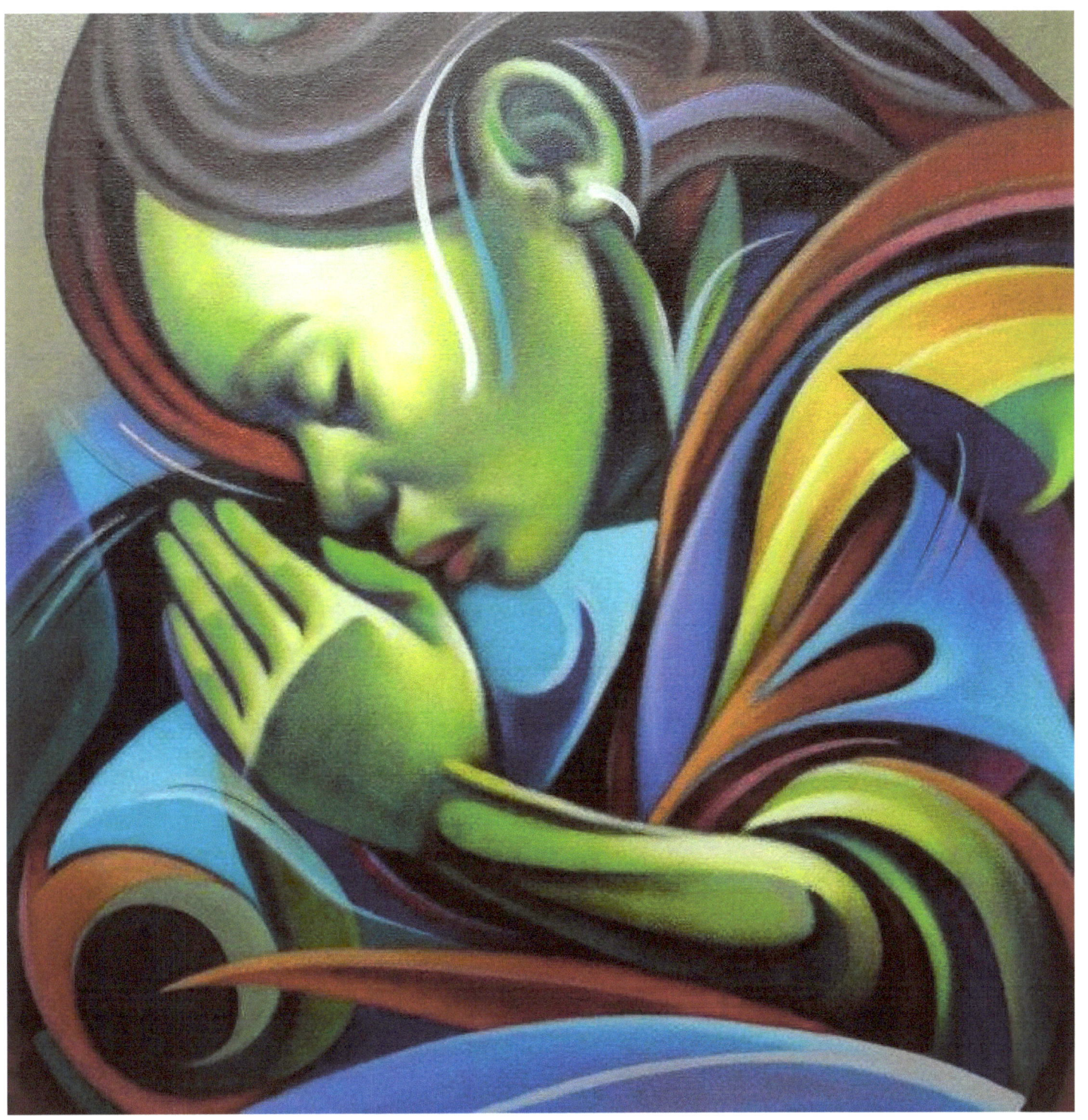

Nik Masangcay, My prayer

Thank you and we hope you enjoyed this artbook. The artist can be contacted at facebook, under NIK MASANGCAY ARTHUB. He can be commissioned to do art work for you. Some of his works are available for sale. Just ask him. This book displays only 40 pieces. He has more than 200 pieces. Each page here can be cut out for framing and wall décor. This artbook is suitable for giveaway or gifts, any occasion. It's suitable for display in sala or living room and coffee table. It's perfect as conversation piece.

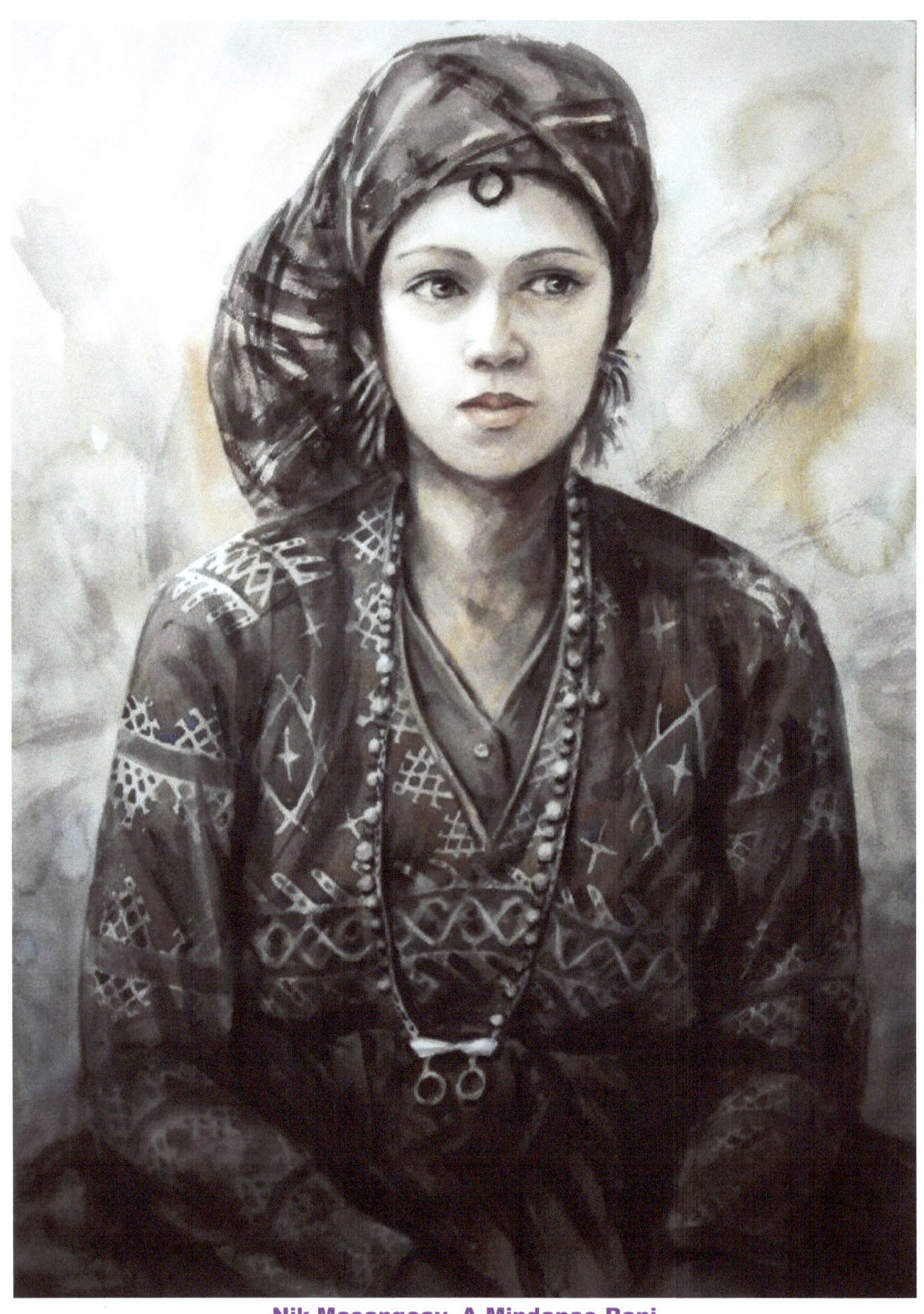

Nik Masangcay, A Mindanao Rani

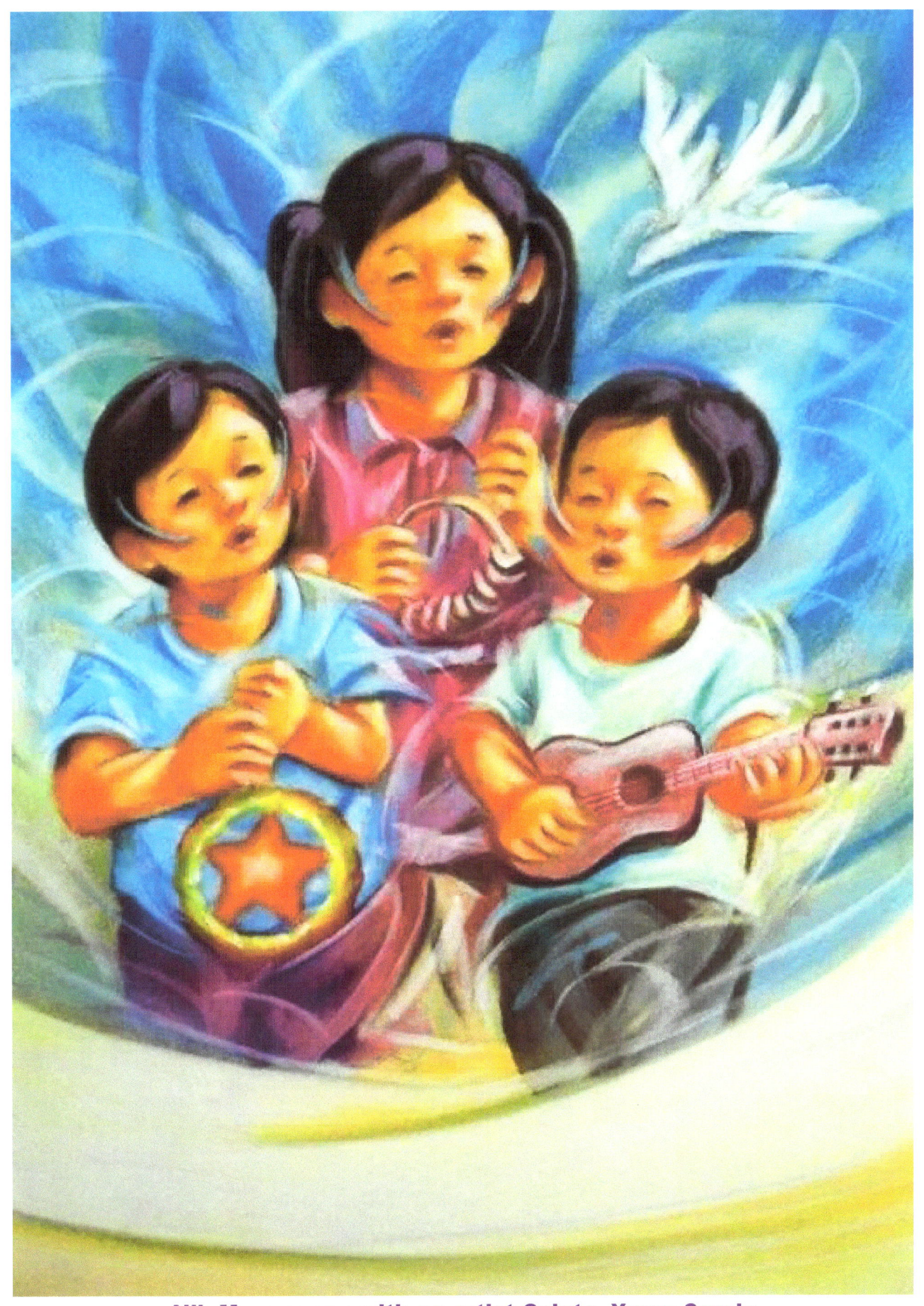

Nik Masangcay with co-artist Calata, Xmas Carols

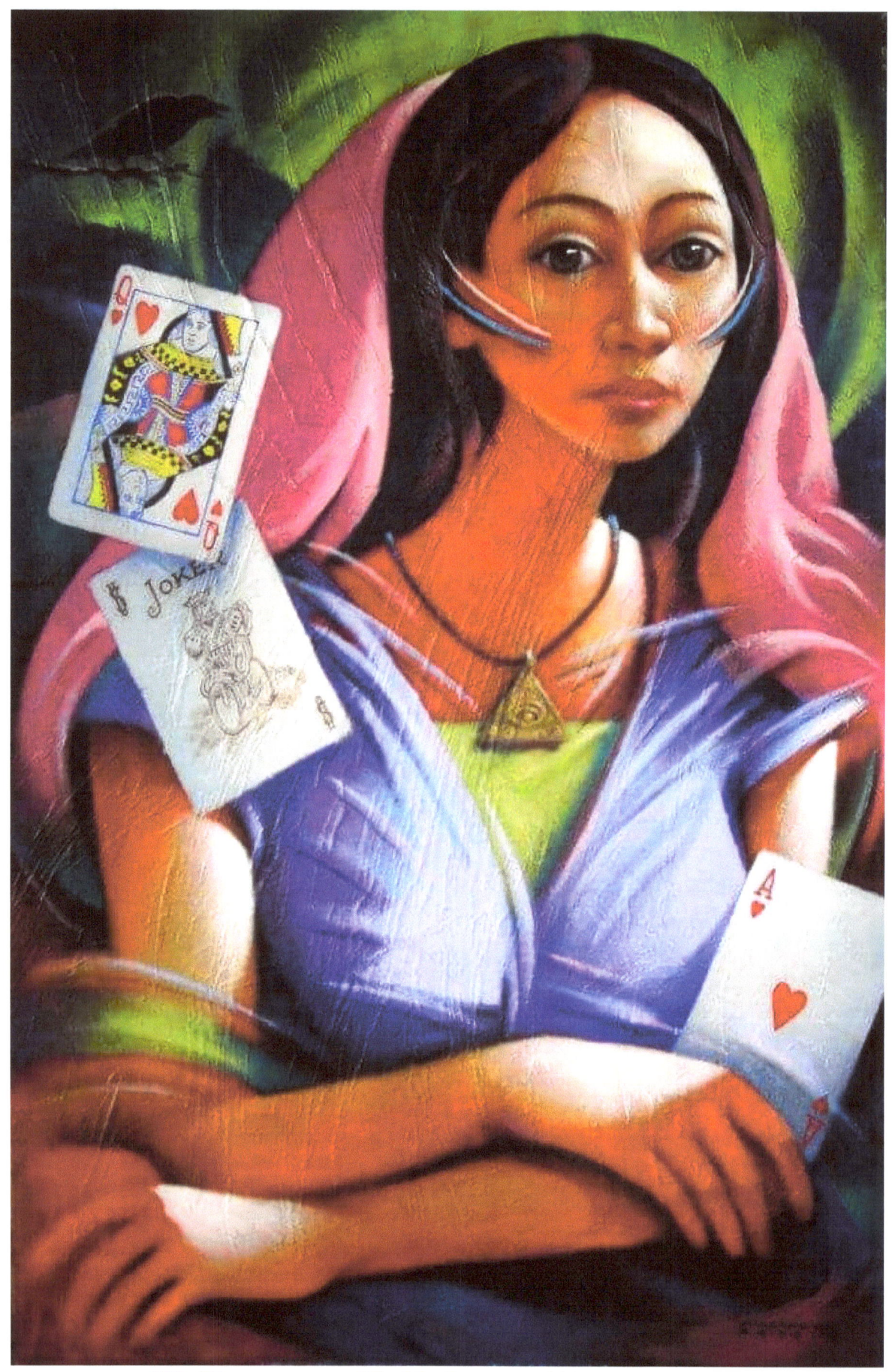

Nik Masangcay, 45x30, Queen of Hearts, acrylic

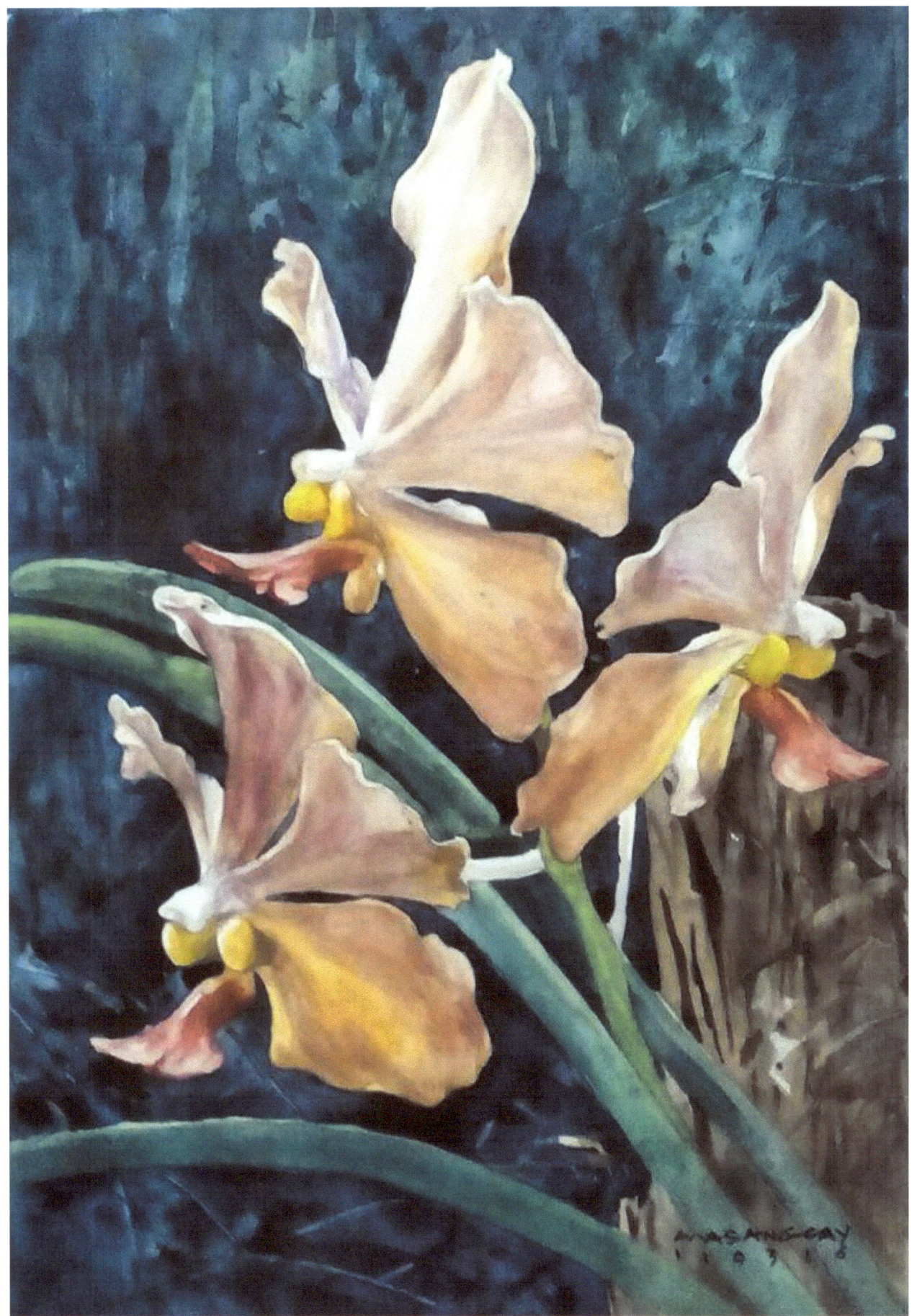

Nik Masangcay, Orchid

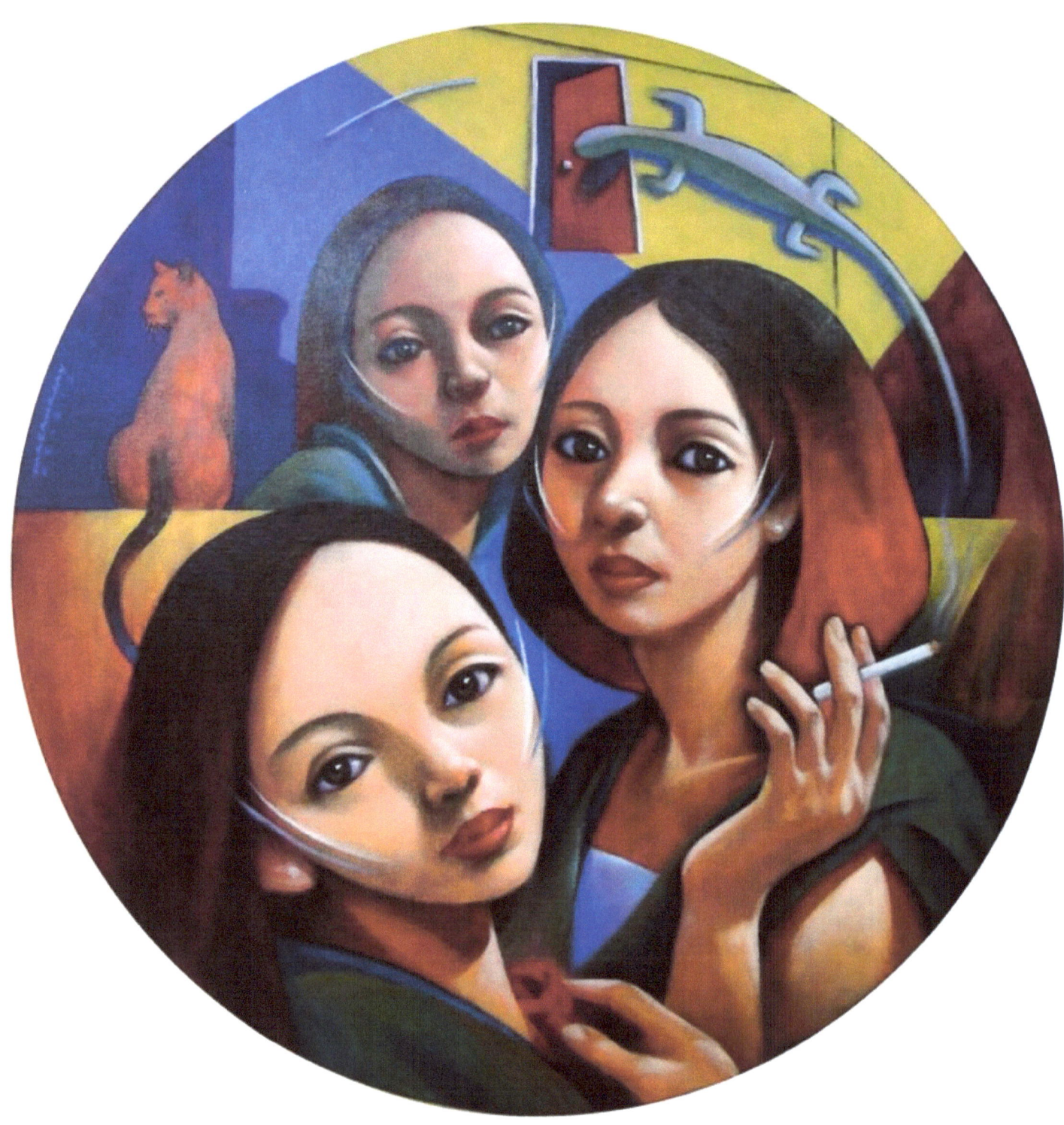

Nik Masangcay, modern ladies

Thank you and we hope you enjoyed this artbook. The artist can be contacted at facebook, under NIK MASANGCAY ARTHUB. He can be commissioned to do art work for you. Some of his works are available for sale. Just ask him. This book displays only 40 pieces. He has more than 200 pieces. Each page here can be cut out for framing and wall décor.

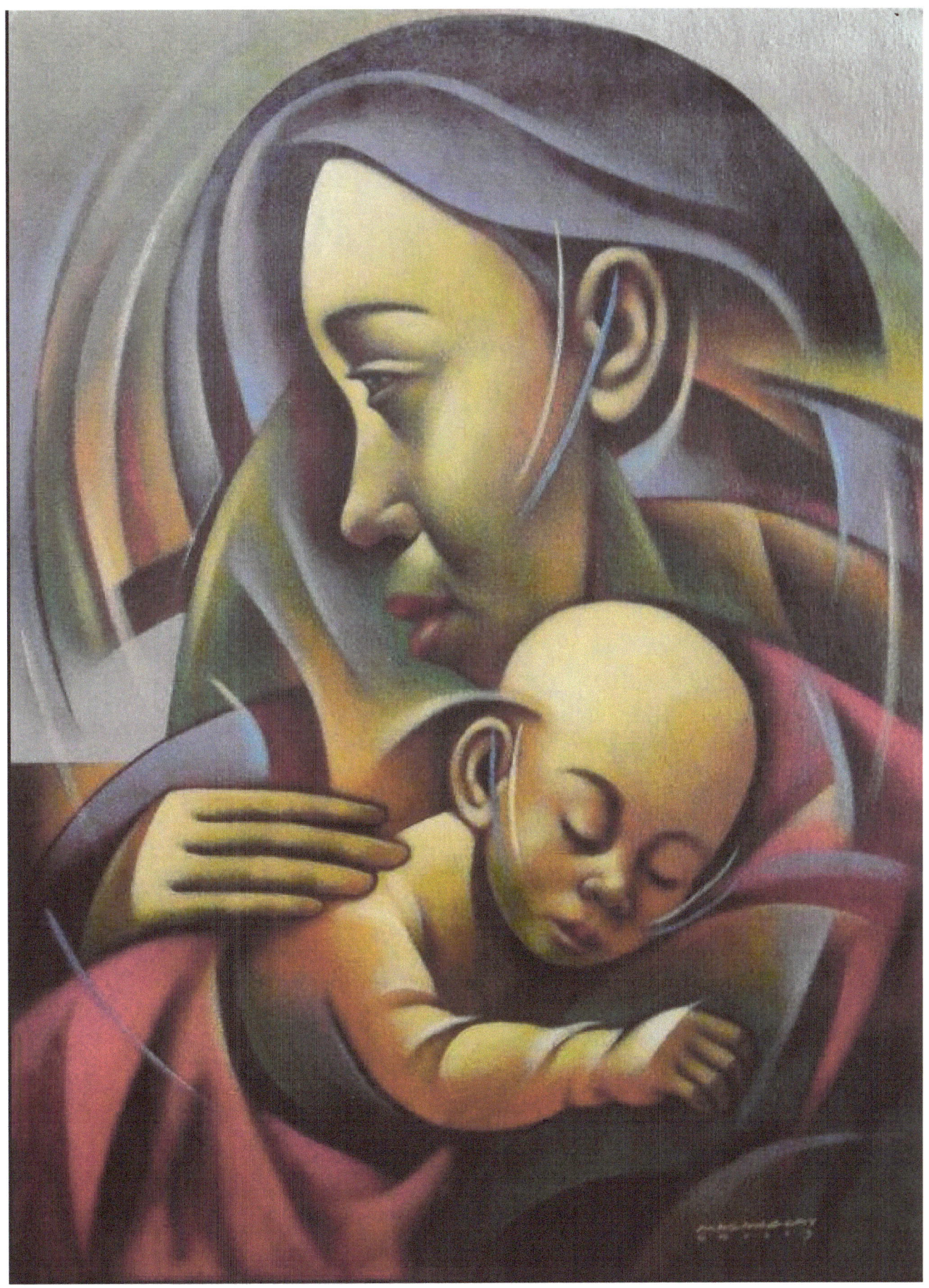

Nik Masangcay, Mother and child

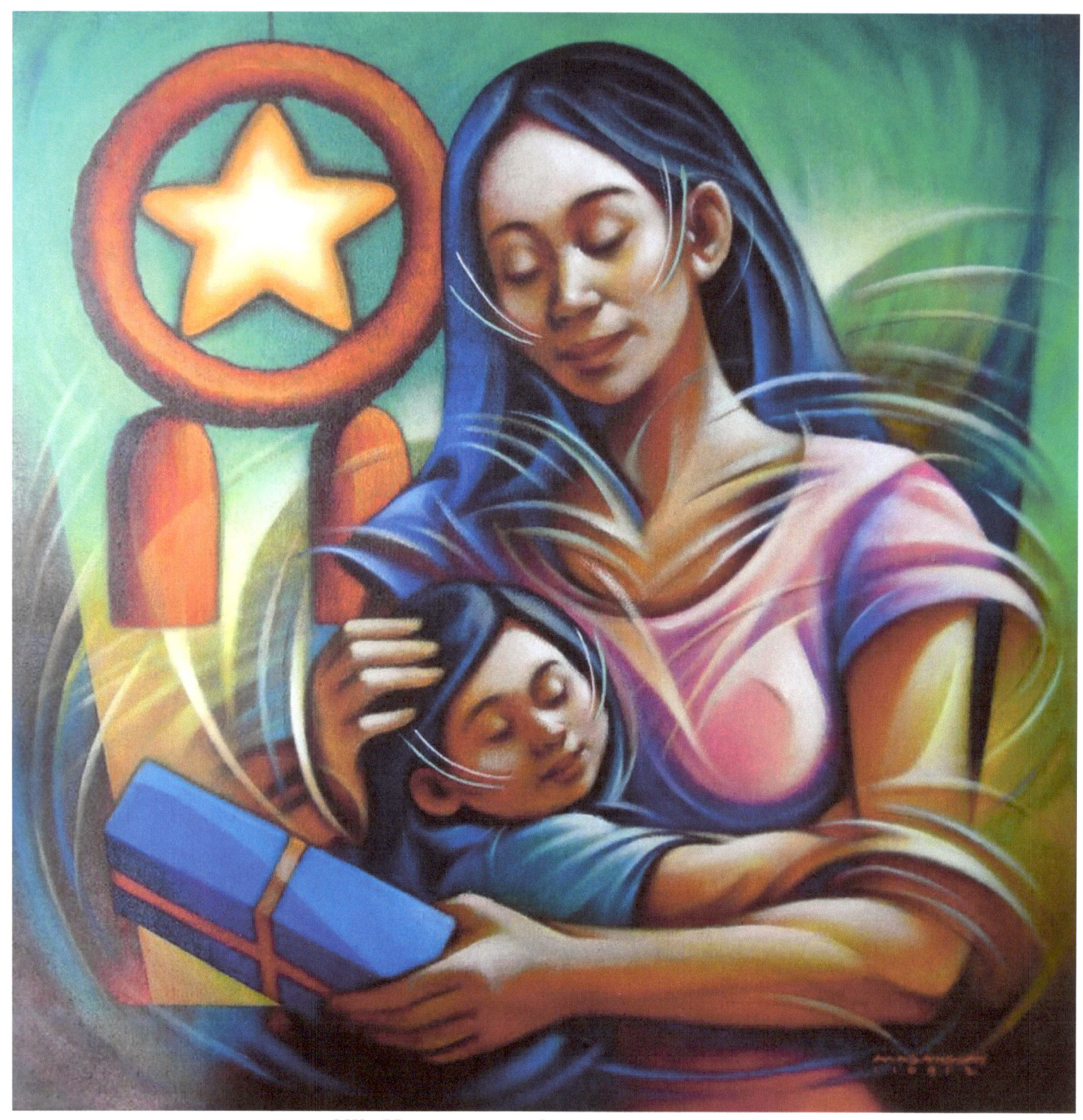

Nik Masangcay, Christmas season

Thank you and we hope you enjoyed this artbook. The artist can be contacted at facebook, under NIK MASANGCAY ARTHUB. He can be commissioned to do art work for you. Some of his works are available for sale. Just ask him. This book displays only 40 pieces. He has more than 200 pieces. Each page here can be cut out for framing and wall décor. This artbook is suitable for giveaway or gifts, any occasion. It's suitable for display in sala or living room and coffee table. It's perfect as conversation piece.

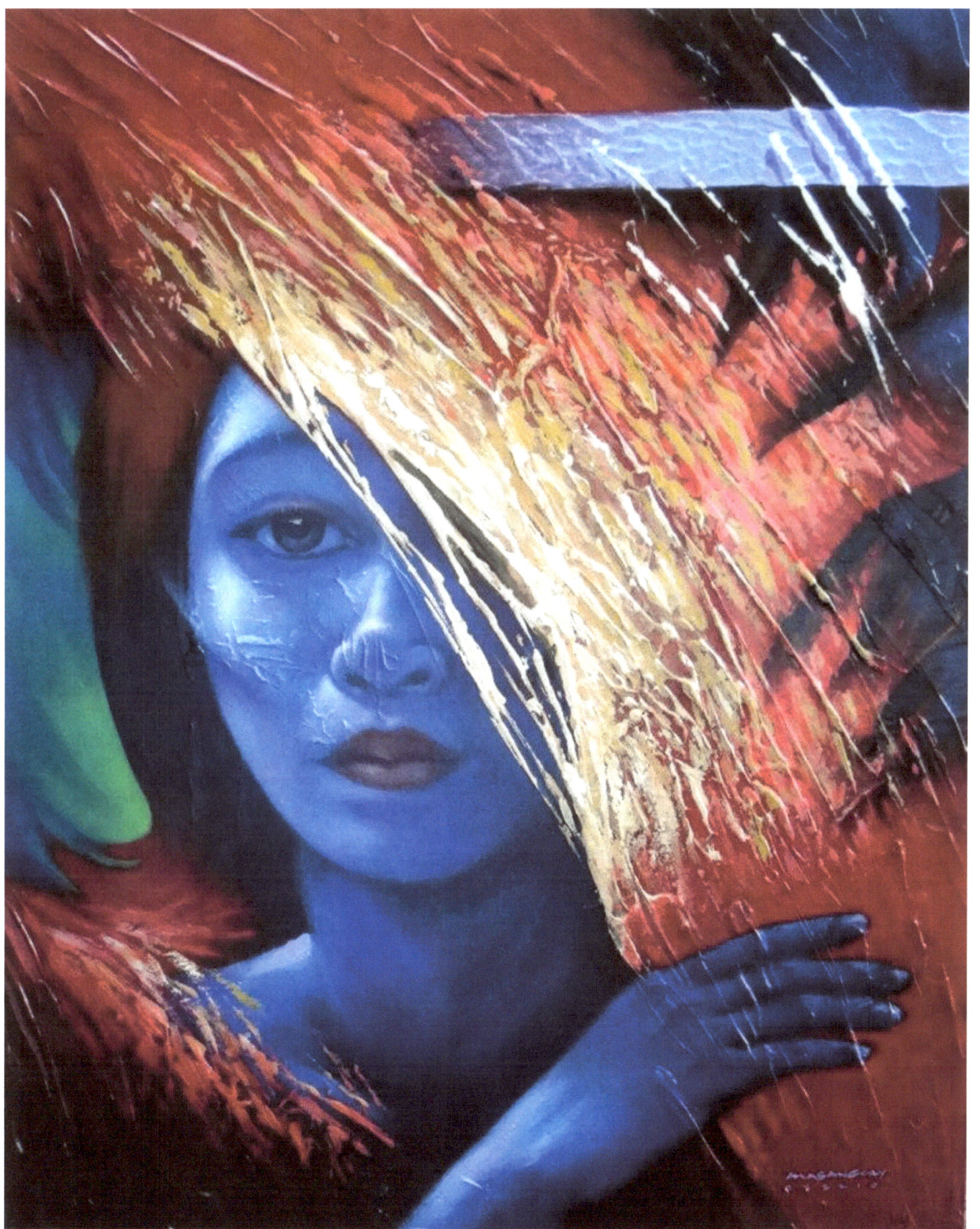

Nik Masangcay, Shy lady

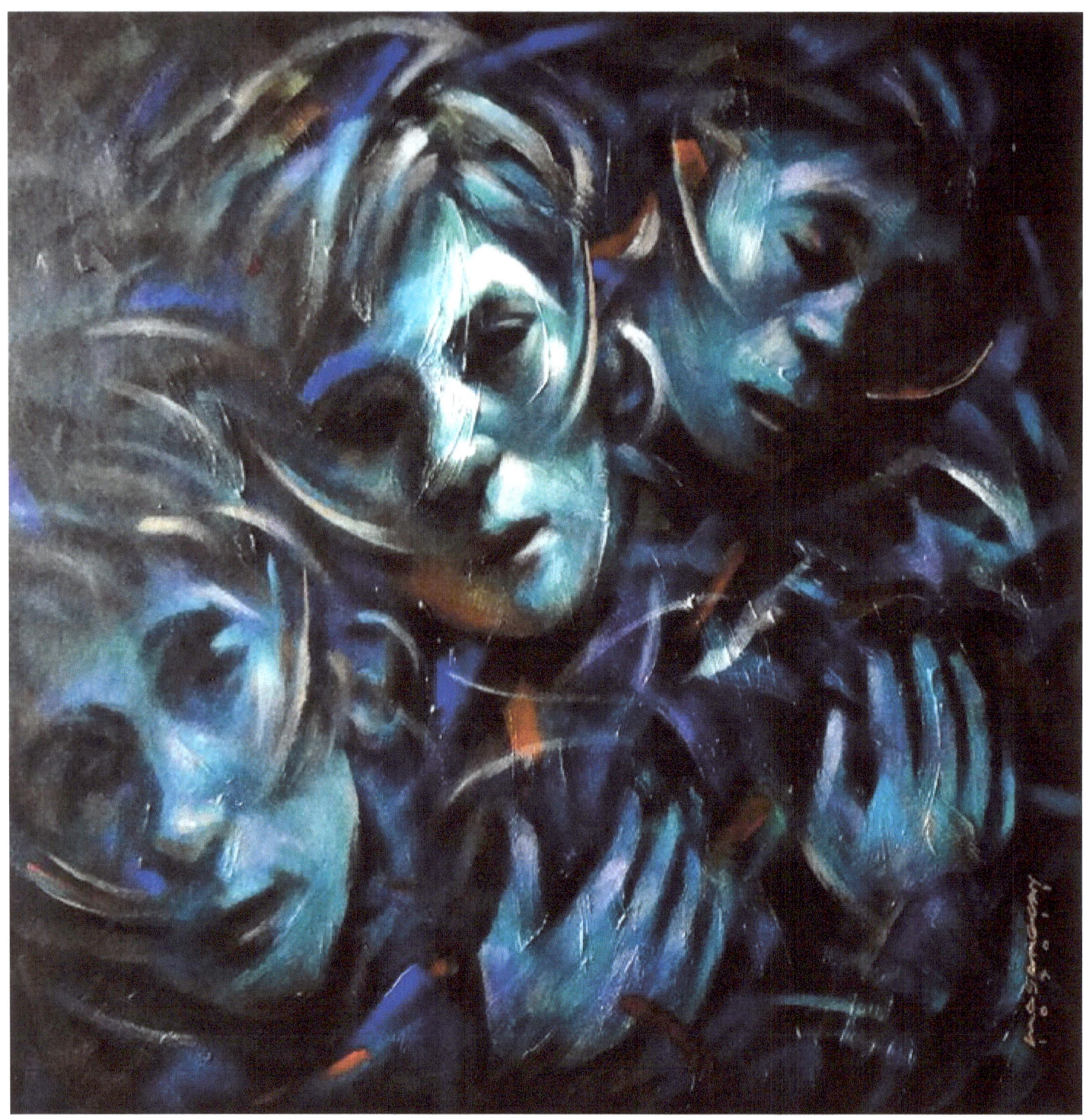

Nik Masangcay, Feelin d blues, 24x24, acrylic

Thank you and we hope you enjoyed this artbook. The artist can be contacted at facebook, under NIK MASANGCAY ARTHUB. He can be commissioned to do art work for you. Some of his works are available for sale. Just ask him. This book displays only 40 pieces. He has more than 200 pieces. Each page here can be cut out for framing and wall décor. This artbook is suitable for giveaway or gifts, any occasion. It's suitable for display in sala or living room and coffee table. It's perfect as conversation piece.

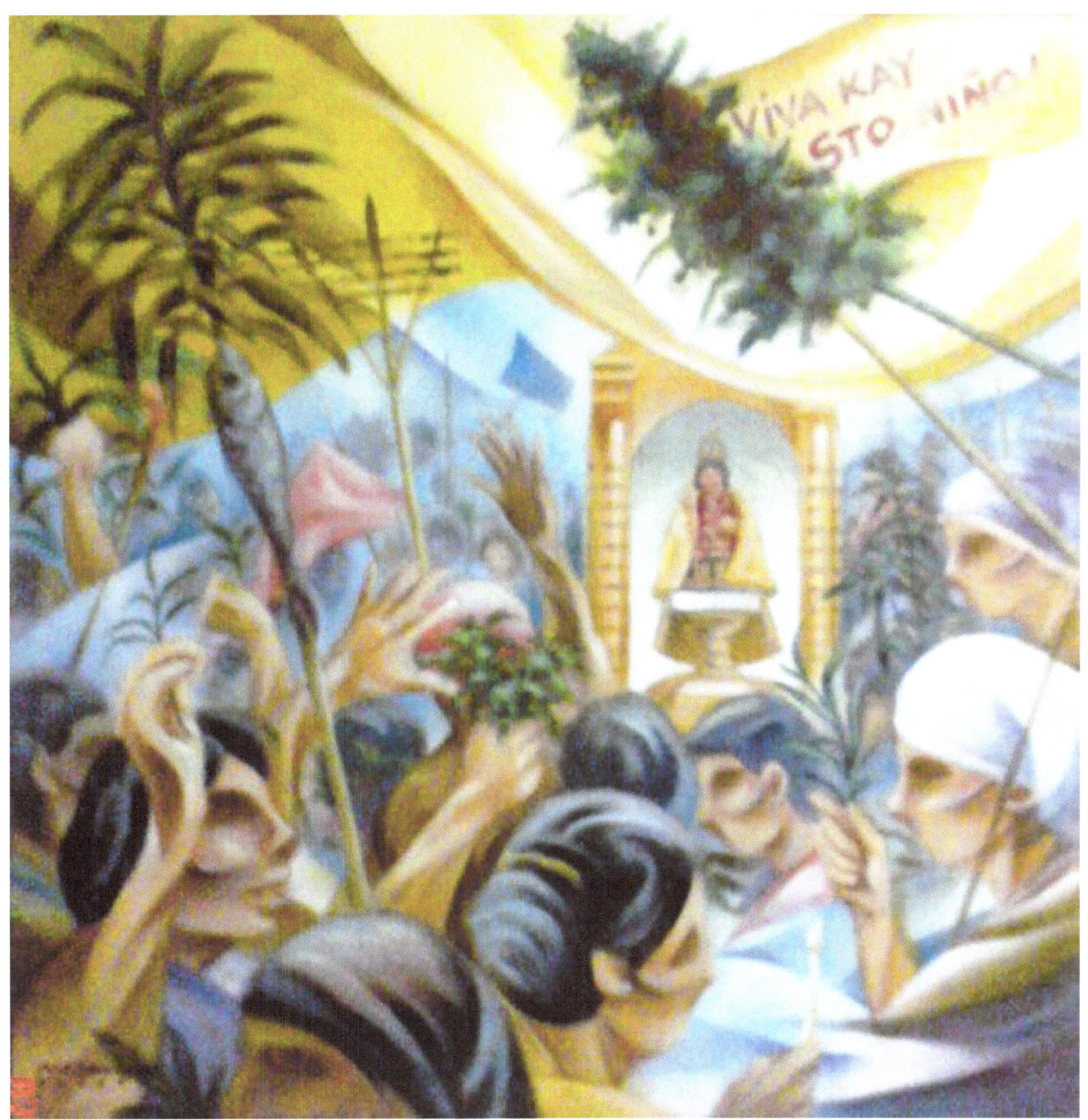

Nik Masangcay, Ibahay, ati-ati, 24x24, acrylic

Thank you and we hope you enjoyed this artbook. The artist can be contacted at facebook, under NIK MASANGCAY ARTHUB. He can be commissioned to do art work for you. Some of his works are available for sale. Just ask him. This book displays only 40 pieces. He has more than 200 pieces. Each page here can be cut out for framing and wall décor. This artbook is suitable for giveaway or gifts, any occasion. It's suitable for display in sala or living room and coffee table. It's perfect as conversation piece.

Thank you and we hope you enjoyed this artbook. The artist can be contacted at facebook, under NIK MASANGCAY ARTHUB. He can be commissioned to do art work for you. Some of his works are available for sale. Just ask him. This book displays only 40 pieces. He has more than 200 pieces. Each page here can be cut out for framing and wall décor. This artbook is suitable for giveaway or gifts, any occasion. It's suitable for display in sala or living room and coffee table. It's perfect as conversation piece.

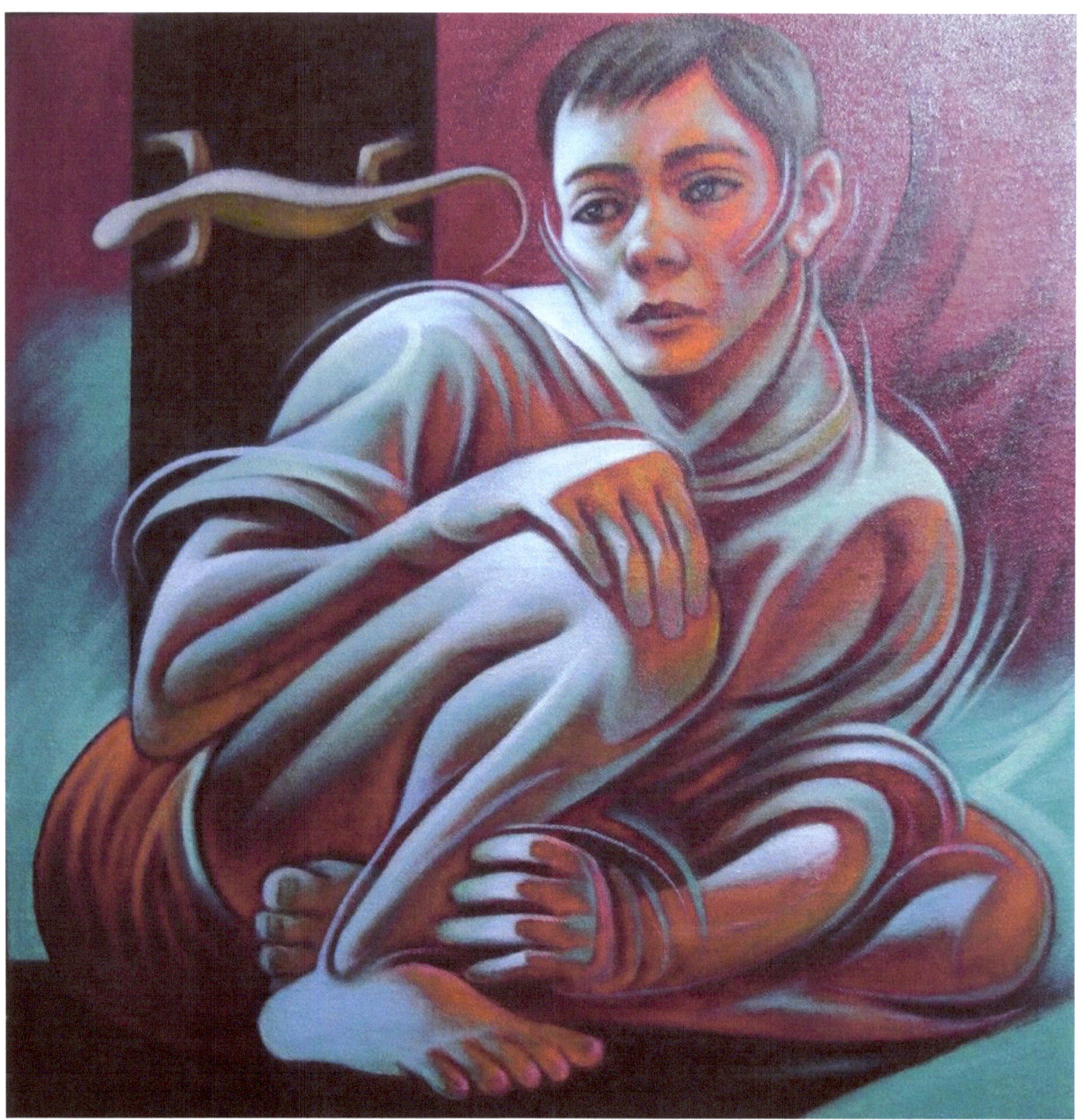

Nik Masangcay, Lie low

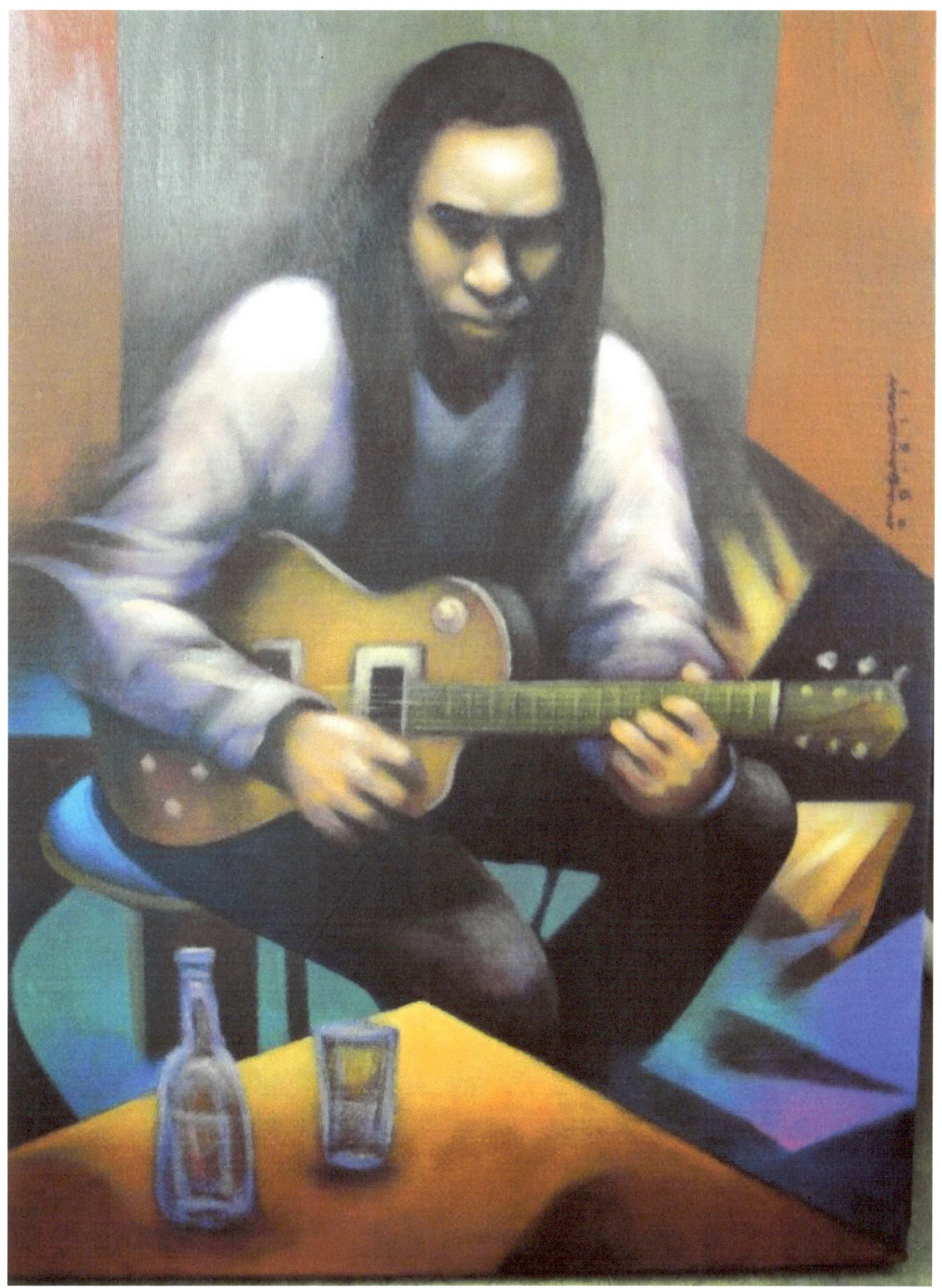

Nik Masangcay, Guiarist

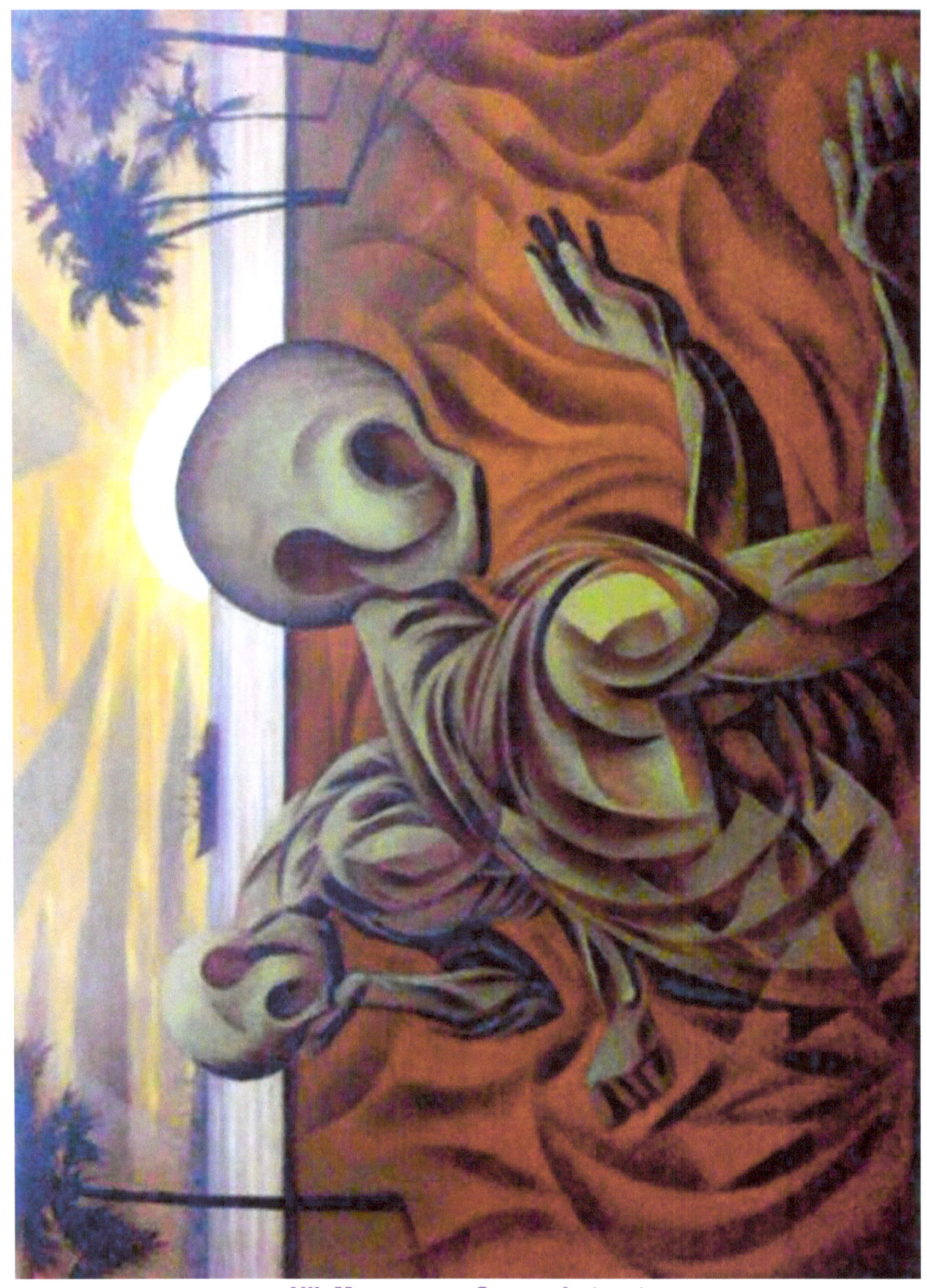

Nik Masangcay, Scary abstract

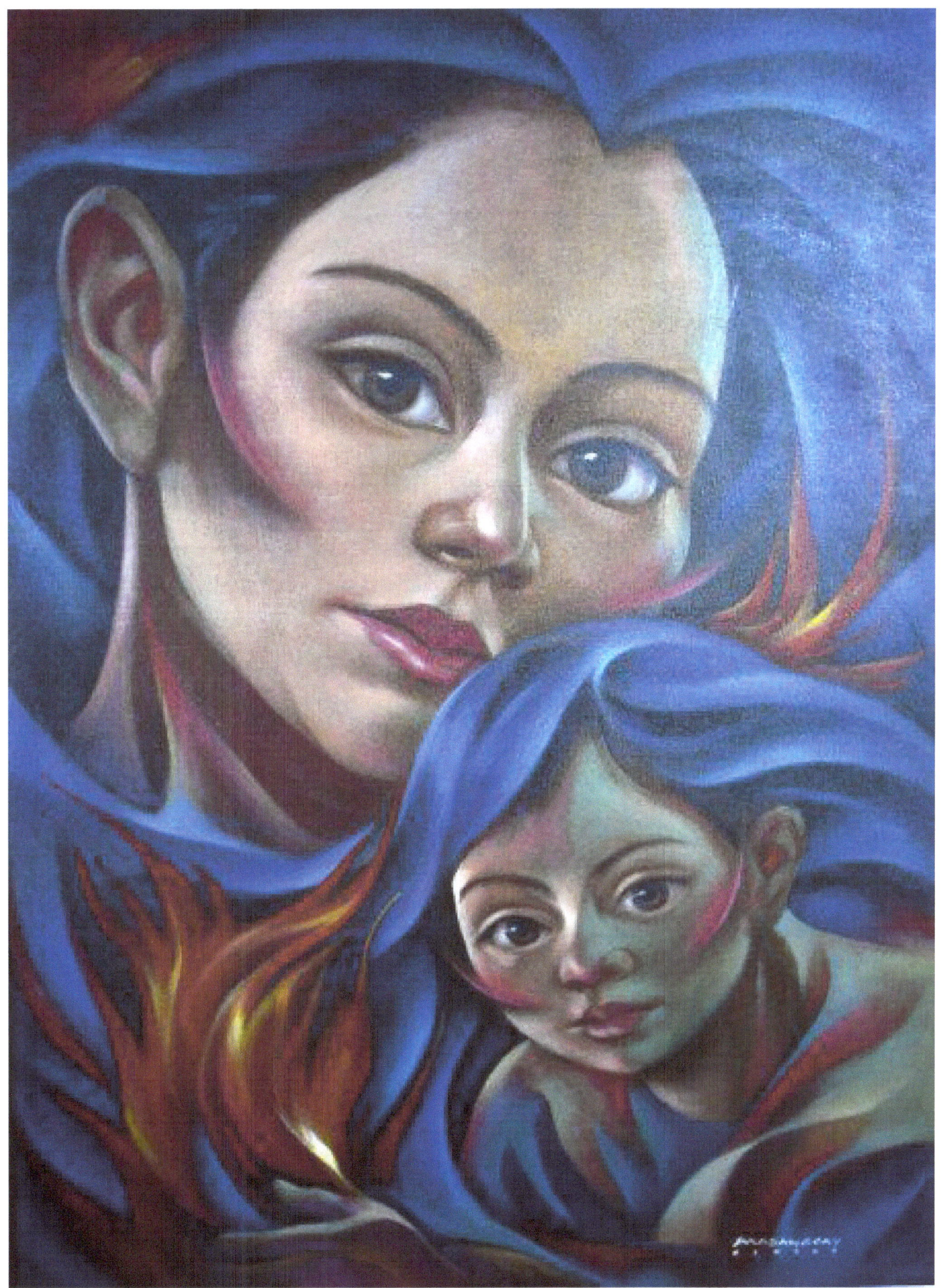

Nik Masangcay, Nanay at Anak

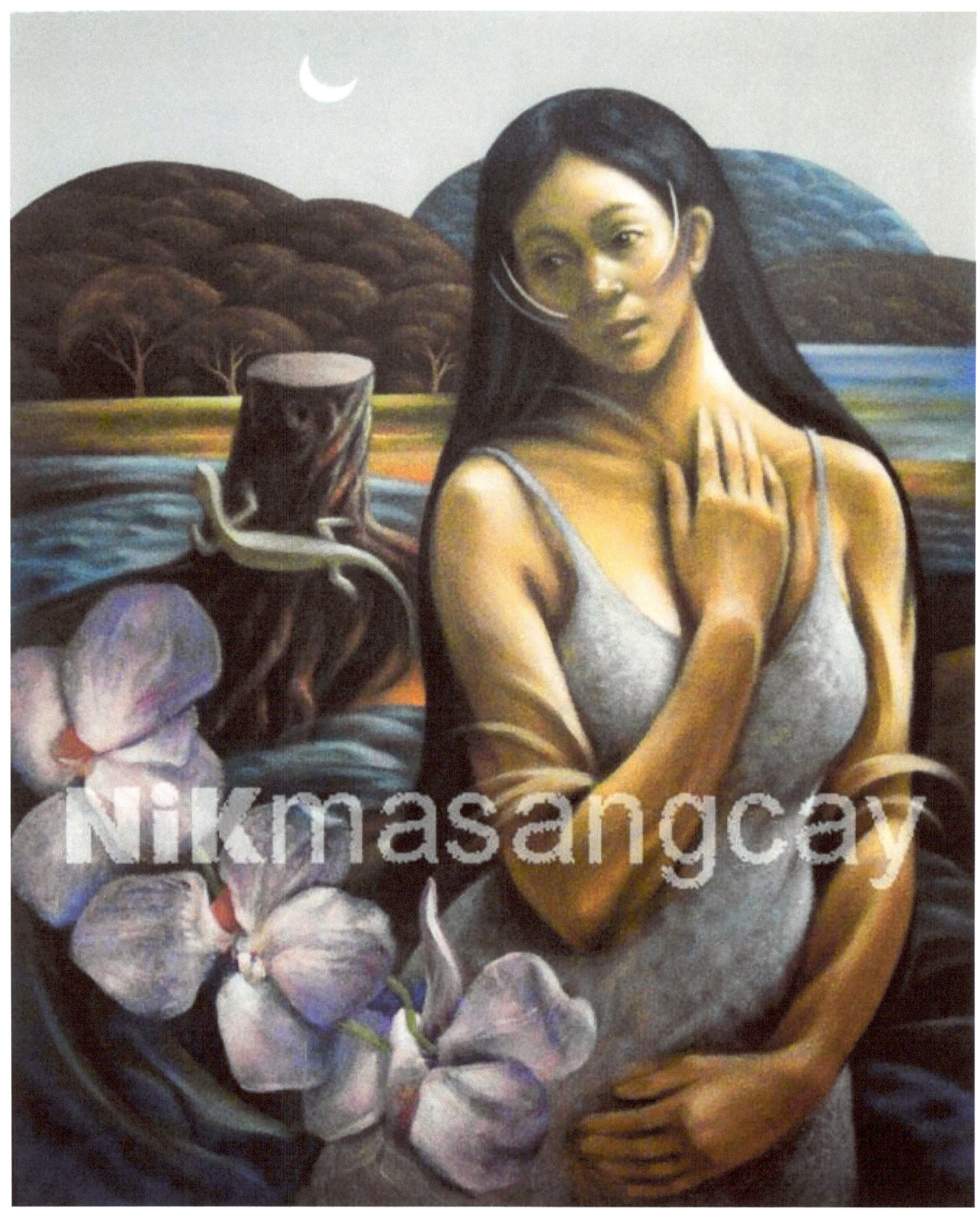

Nik Masangcay, Symbolic Logo

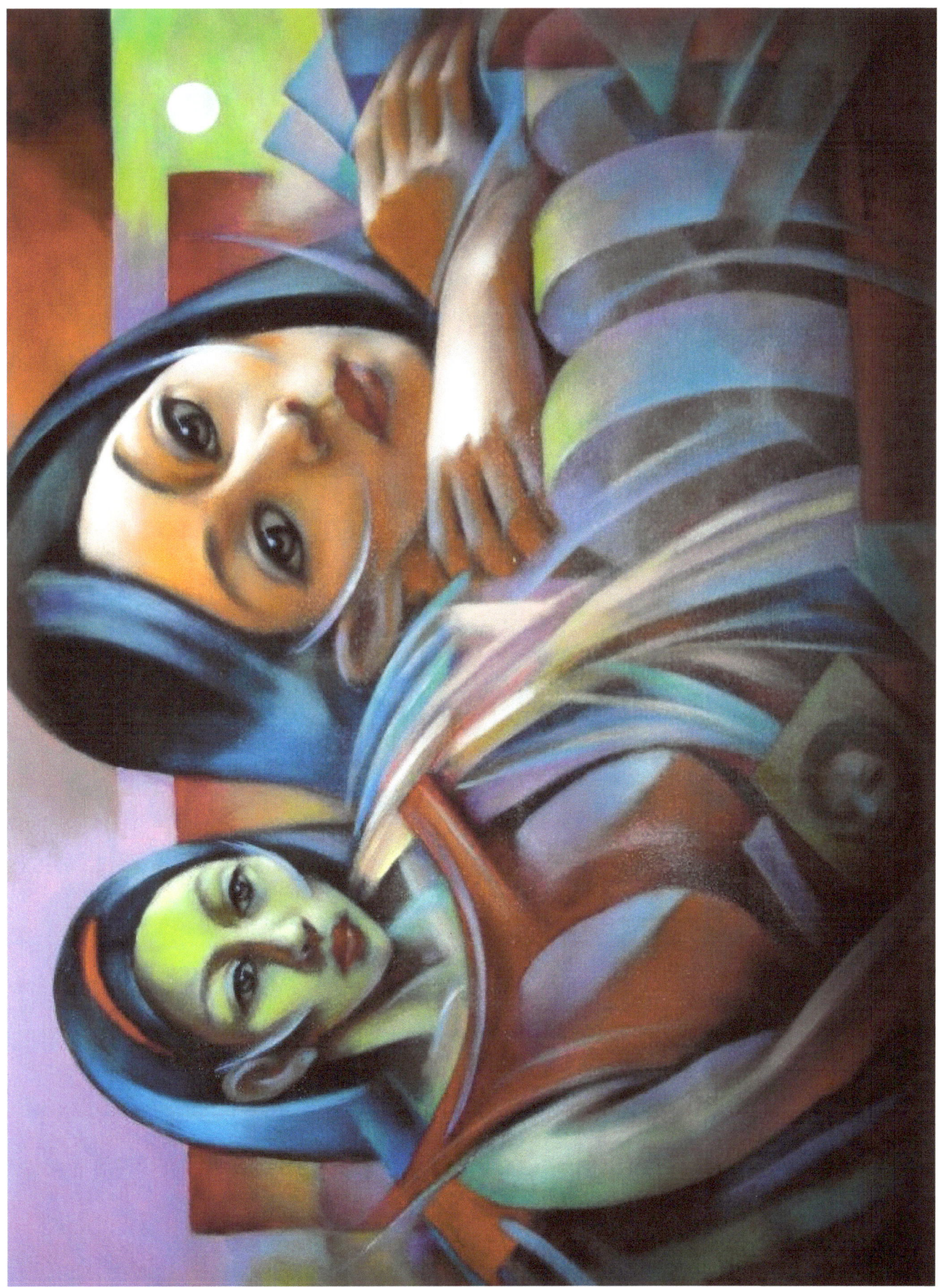

Nik Masangcay, Patient ladies

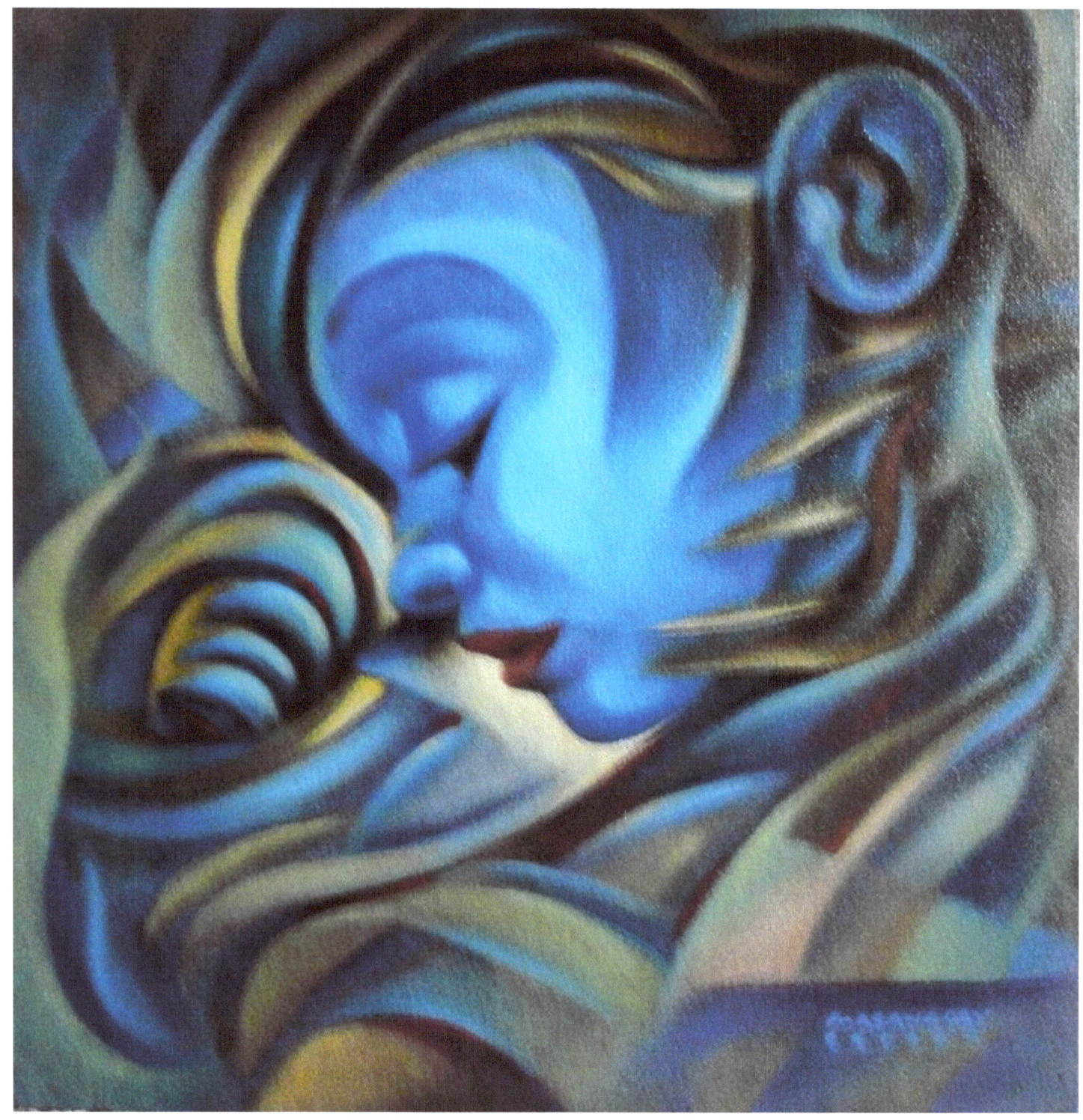

Nik Masangcay, Lonesome lady

Thank you and we hope you enjoyed this artbook. The artist can be contacted at facebook, under NIK MASANGCAY ARTHUB. He can be commissioned to do art work for you. Some of his works are available for sale. Just ask him. This book displays only 40 pieces. He has more than 200 pieces. Each page here can be cut out for framing and wall décor. This artbook is suitable for giveaway or gifts, any occasion. It's suitable for display in sala or living room and coffee table. It's perfect as conversation piece.

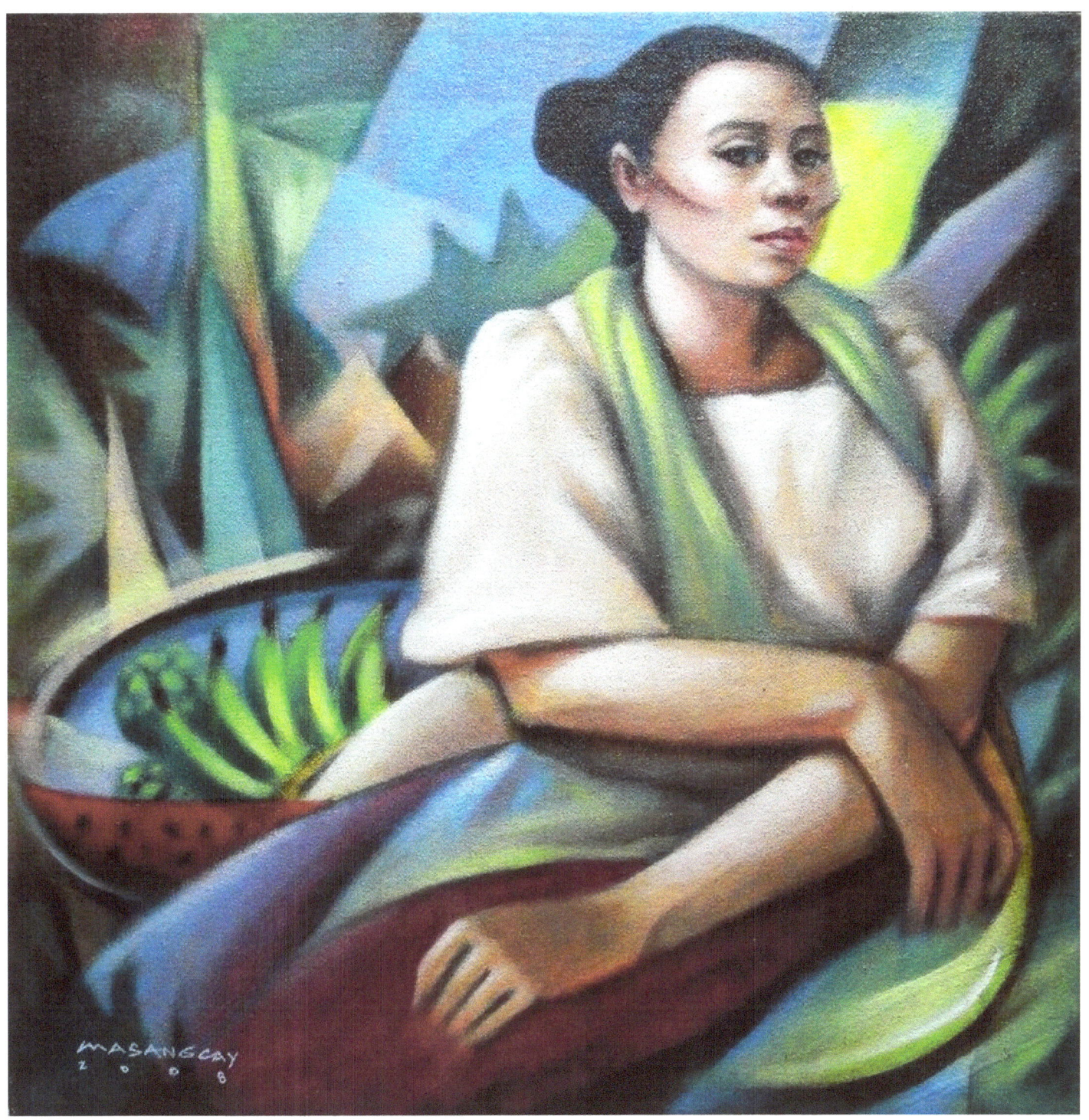

Nik Masangcay, Fruit Vendor

Thank you and we hope you enjoyed this artbook. The artist can be contacted at facebook, under NIK MASANGCAY ARTHUB. He can be commissioned to do art work for you. Some of his works are available for sale. Just ask him. This book displays only 40 pieces. He has more than 200 pieces. Each page here can be cut out for framing and wall décor. This artbook is suitable for giveaway or gifts, any occasion. It's suitable for display in sala or living room and coffee table. It's perfect as conversation piece.

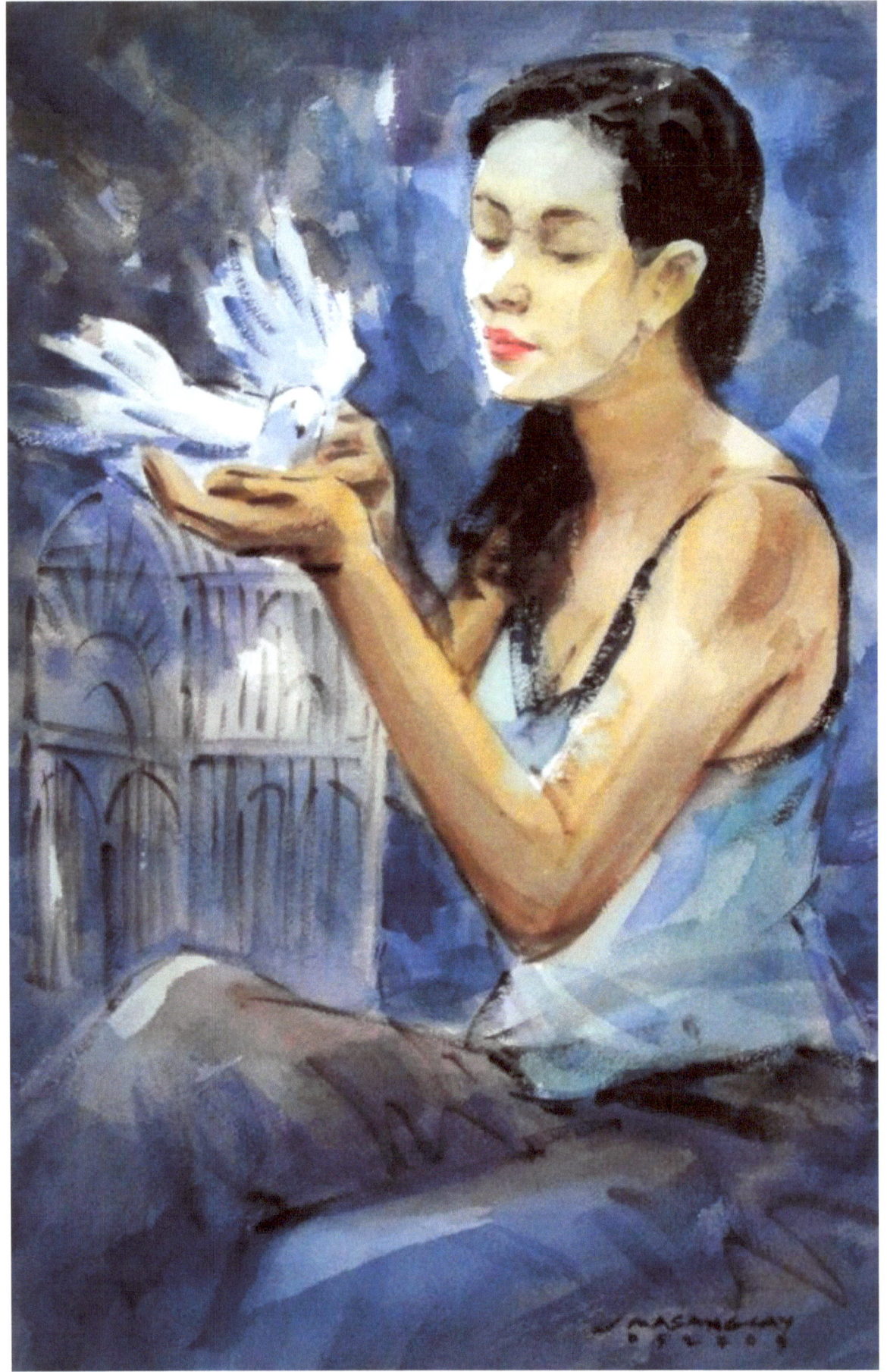

Nik Masangcay, bird feeding

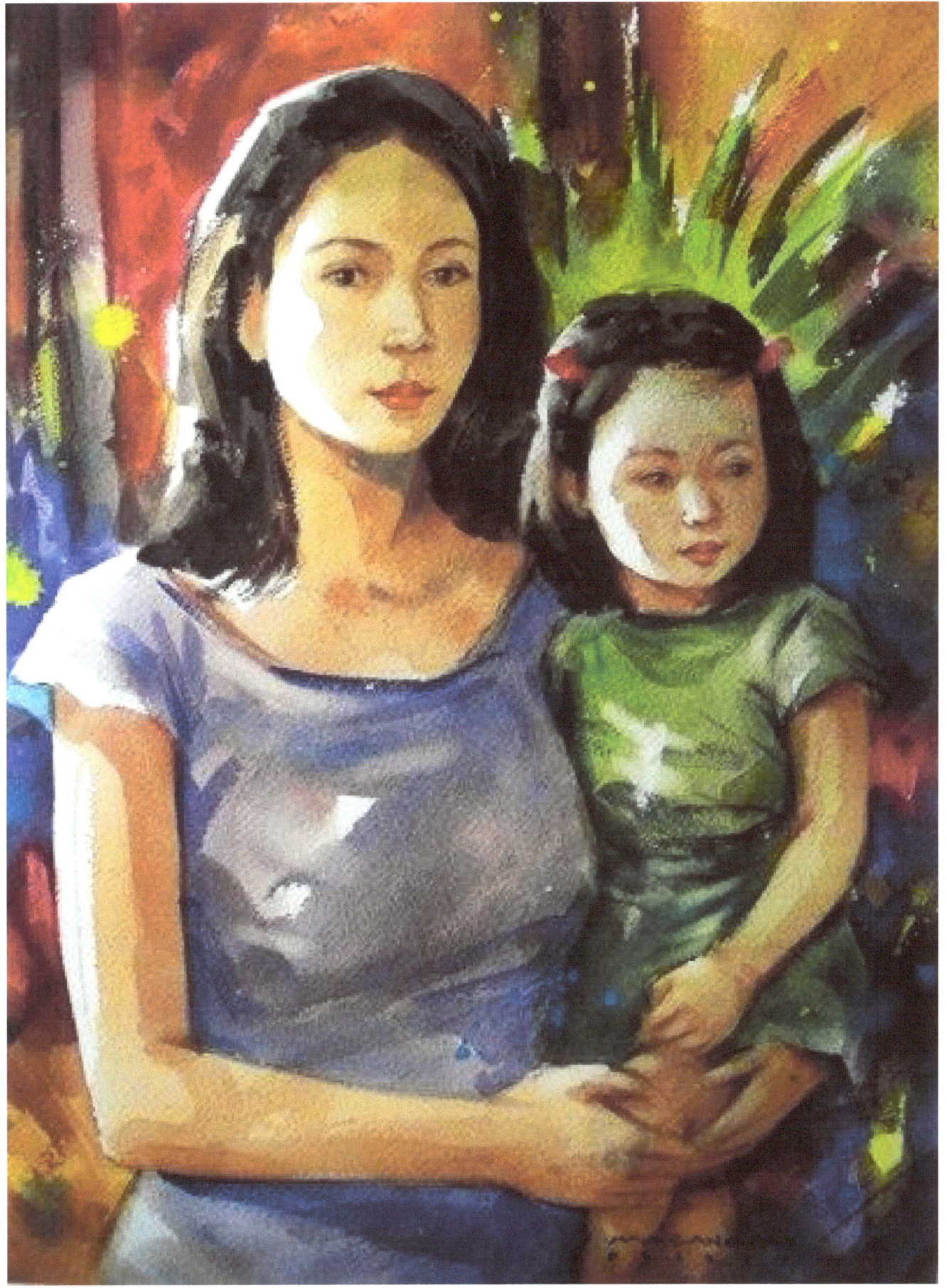

Nik Masangkay, Nanay and Neneng

Thank you and we hope you enjoyed this artbook.
The artist can be contacted at facebook, under
NIK MASANGCAY ARTHUB
He can be commissioned to do art work for you.
Some of his works are available for sale. Just ask him.
This book displays only 40 pieces. He has more than 200 pieces.
Each page here can be cut out for framing and wall décor.
This artbook is suitable for giveaway or gifts, any occasion.
It's suitable for display in sala or living room and coffee table.
It's perfect as conversation piece.

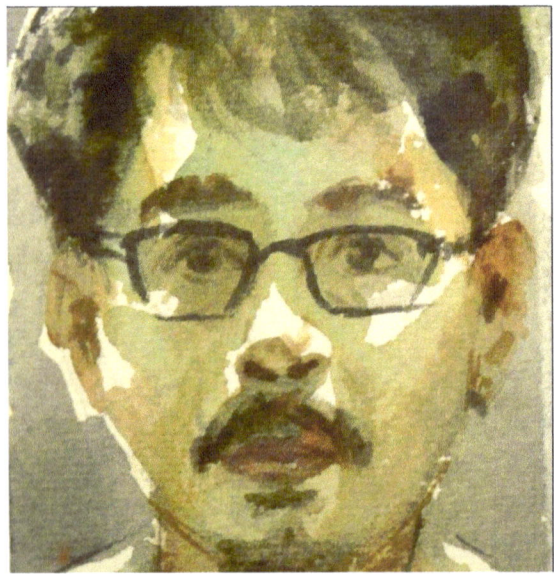

Maraming salamat po.

www.ingramcontent.com/pod-product-compliance
Lightning Source LLC
Chambersburg PA
CBHW051105180526
45172CB00002B/789